Make Way *for* Nancy

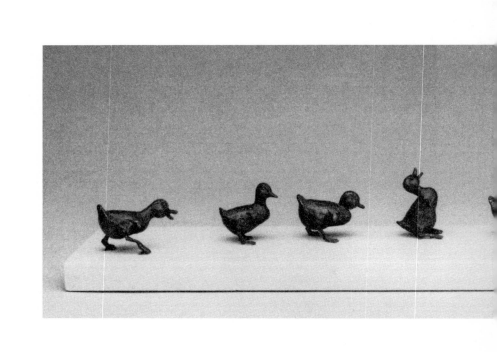

Make Way *for* Nancy

A Life in Public Art

NANCY SCHÖN

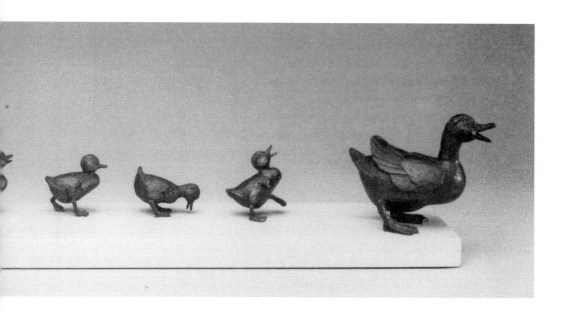

DAVID R. GODINE, *Publisher*

BOSTON

First published in 2017 by

David R. Godine • Publisher

Post Office Box 450

Jaffrey, New Hampshire 03452

www.godine.com

Library of Congress Cataloging-in-Publication Data

Names: Schön, Nancy, 1928- author.

Title: Make way for Nancy : a life in public art / Nancy Schön.

Description: Jaffrey, New Hampshire : David R. Godine, Publisher, 2017.

Identifiers: LCCN 2017021300 | ISBN 9781567926064 (alk. paper)

Subjects: LCSH: Schön, Nancy, 1928- | Sculptors--United States--Biography.

| Women sculptors--United States--Biography. | Public sculpture--

United States.

Classification: LCC NB237.S377 A2 2017 | DDC 730.92 [B] --dc23

LC record available at https://lccn.loc.gov/2017021300

First edition

Printed

in the

United States of America

Table of Contents

This book is dedicated with all my love:

To my husband, Don, who made me smart and let me make him popular.
To Ellen, who helped me learn to be a mother.
To Andy, who caught my heart for seeing my fingerprints in bronze.
To Bootsie, whose wisdom keeps us honest.
To Susie, whose creative eye inspires us all.

I am grateful to these five most important people in my life, and I delight in our growing family of grandchildren and great grandchildren, each of whom I deeply cherish.

Foreword

I'VE ALWAYS LIKED MAGIC.

When my daughter was three years old, we made countless outings to feed the ducks. She would laugh as they snapped up our old crusts and crumbs. She giggled at the way they waddled, and when they dove underwater she watched for them to reappear safely. To her it was all amazing: the flapping, squabbling, and quacking endlessly entertaining.

But sometimes she ignored the ducks altogether, focused instead on nearby squirrels and pigeons – creatures a grown-up might dismiss as ordinary moochers, certainly not worth a trip to the pond. But on good days, I crouched down beside my little girl and saw the pigeons as she saw them: amazing.

Nancy Schön's famous ducks are like that. Each one is a carefully wrought individual, anatomically correct, and true to nature in every detail. They are not cartoons. They are not "cute." They are just ducks – but ducks the way my daughter taught me how to see them.

None of Nancy Schön's creatures wear clothing, her raccoons do not grin, and her bear does not wink. And because they are true to nature and – best of all – because we can touch them, they enable us to experience wonder. Even in the age of Pixar and 3-D animation, Nancy's silent, motionless bronze sculptures are joyful and consoling. And if you visit *Make Way for Ducklings* in the Boston Public Garden and (this is important) wait and watch until your heart opens, they are magic.

"persistence, tenacity, honesty, patience, determination, endurance, commitment, and stamina!"

Boston may be booming but it's still small enough to prove the "six degrees of separation" theory that you can connect any two people by no more than six relationships. (My niece goes to school with a kid whose baby-sitter's mother works for your boss.) Nancy Schön and I—both residents of Newton, just west of Boston—were less than once removed. We had many friends in common, who introduced us any number of

times. We would always acknowledge our mutual admiration, and, for years, promised to get together.

I regret how long that took, but we finally made a date. Nancy invited me to visit her in the grand old house where she raised four children and where sculptures of giraffes, pigs, and graceful human forms take you by surprise in every room. After tea in the kitchen, we went to her studio – a reconstructed garage in the backyard. It's spacious and bright and full of a comfortable clutter of art stuff: drawings and photographs are tacked on the walls and laid out on worktables; there are tools for wax and clay; and on the metal shelving, maquettes (scale models in wax) and small bronzes. Decades of work are on display, including small, elegant pieces commissioned by non-profit organizations as gifts to donors, tender statues of women and children, figures and scenes of Jerusalem. There are stories attached to every piece, chapters of an autobiography in art.

Nancy explained the basics of her method for casting bronze, the "lost wax" process, which sounds like an ancient mystery and does involve a complicated alchemy that requires talent, craft, hard work, and patience.

I saw evidence of her most familiar public art pieces in various stages of development. There were orphans, too: maquettes and drawings of large-scale projects that were not chosen in a competition or wait for patrons and funding.

Like all artists, Nancy needs quiet and solitude to create, but making public art is a contact sport. She has to spend a great deal of time proposing projects, applying for commissions, and helping identify and woo potential donors. It took ten years for *Make Way for Ducklings* to go from an idea to a beloved icon; ten years that included countless hours at committee meetings and public hearings, correspondence and negotiations with politicians, geologists, stonemasons, and many others. It took seven years for *Tortoise and Hare* to finish their race in Copley Square, near the Boston Marathon finish line.

Having learned about these long and winding roads, I now see public art with with an appreciation for the obstacles, paperwork, and drama involved – though surely none more byzantine and complicated than the cloak and dagger saga Nancy tells of how those ducklings got to Moscow.

Public art, says Nancy, "takes persistence, tenacity, honesty, patience, determination, endurance, commitment, and stamina." Nancy personifies all of these qualities. Add to the list, "energy" and another essential ingredient. "For me, what has made all the difference is that I love what I do."

Love begets love.

Boston Globe architecture critic Robert Campbell has written, "There are a dozen statues in the Boston public garden, mostly of dignified early Americans. George

Washington's is the biggest, but the best loved is the one by sculptor Nancy Schön of the feathered family from Robert McCloskey's children's book, *Make Way for Ducklings.*"

"I want my work to bring a smile or solace – the consolation and joy of something magical."

A trio of storybook characters stands outside the Newton Free Library. The children who climb on Eeyore's back, pat Winnie-the-Pooh's tummy, and whisper in Piglet's ear have no idea that their silent playmates are memorials to a four-year-old son, a 20-year-old daughter, and a 21-year-old brother. It's not common knowledge among the adults, either.

Most memorial art is formal and distant: obelisks and angels up on pedestals, majestic tributes to kings, generals, presidents, and fallen soldiers. Nancy Schon brings loss into the thick of life, where grief and happiness are always braided together. So in a New Hampshire park, children jump on a bronze sled in memory of a lost child who never came home. In Naples, Florida, and Dorchester, Massachusetts, there are memorial dragons that practically demand a game of make-believe. Writing about that dragon, the Boston Art Commission called Nancy Schön, "a leader in the new genre of play sculpture."

She says, "I probably don't need to add how proud I am of that."

"Making the 24 maquettes [for the fables] felt like creating a legacy."

Nancy had an ulterior motive for inviting me to her house. She knew that I was in a creative slump – the book I was writing wasn't going so well. She knows what that's like. "It's a cycle for me. Anger, crying, feeling worthless, and then getting charged up and active again." She wanted to offer first-hand encouragement – in bronze.

After a long period without any assignments to keep her in the studio Nancy decided to charge herself up by undertaking an ambitious project unlike anything she'd ever done before: a series of tableaux representing twenty-four Aesop's fables – one for each letter in the Greek alphabet.

She selected fables that "wowed" her; fables populated by birds, frogs, foxes, women, men and one Greek god.

This was a huge undertaking and a labor of love with no guarantee of compensation for her time, work, and the substantial cost of working in bronze.

She found joy in researching and recreating the anatomy of a new menagerie of creatures, of fashioning the maquettes, and of seeing them cast in bronze. I ran my fingers over the critters, I studied them from every angle on the obliging turn-

tables, I leaned in, grinned, oohed, and ahhed like a three-year-old.

I offered to help Nancy polish the short, written versions that accompany her fables. She worried that it would mean neglecting my own writing, which I suppose it did. But I couldn't resist the fun of staying connected to those sculptures and stories and I wanted the pleasure of working with Nancy on her labor of love.

It was a fun project, which got me out of my funk, which helped me finish my book.

On a recent spring day, I visited the Boston Public Garden and walked over to *Make Way for Ducklings*. Children hugged the ducklings, a grinning mom with two toddlers on her lap sat on Mother Mallard's back, people stopped to take pictures and smile at each other. A local man told a couple of tourists about Robert McCloskey's book and explained that the little bonnets were left over from Easter.

Nancy Schön works in bronze, but her legacy is made of warmer stuff; joy, magic, consolation, play, solace, connection, and love.

– Anita Diamant

Public Art by Nancy Schön

Make Way for Ducklings, Boston, 1987

Make Way for Ducklings, Moscow, 1991

Eeyore, Newton, Massachusetts, 1991

Tortoise and Hare, Boston, 1995

Raccoons and the Magic Horseshoes, Belle Meade, Tennessee, 1995

The Joy of Children, Wayland, Massachusetts, 1996

Pooh, Newton, Massachusetts, 2001

Lentil and His Dog Harmony, Hamilton, Ohio, 2001

Dragon, Naples, Florida, 2001; Dorchester, Massachusetts, 2003

Sundial, Boston, 2004

Butterflies, Boston, 2008

Tortoise and Hare, Crystal Bridges Museum, Bentonville, Arkansas, 2009

(permanent installation, 2012)

Sal's Bear, Boothbay, Maine, 2010

Piglet, Newton, Massachusetts, 2012

Friendship, Oklahoma City, 2014

Other works mentioned in this book:
The Reflective Giraffe
Bacon (based on Piggy-Wig from "The Owl and the Pussycat")
Aesop's Fables

Introduction

PEOPLE ARE ALWAYS ASKING ME, "When did you start making sculptures?"

When I was little, my hands were constantly putting things together, which is true for most kids, I think. At a Halloween party in second grade, each child was given a stick of gum, told to chew it, and then make a sculpture from it. (That must have been the first time I heard the word "sculpture.") I made a tiny cup and saucer and won first prize.

Around age ten, I fell in love with Michelangelo, whose drawings, paintings, and marble sculptures I could only have seen in books. I never dreamed I'd later see his works in person. I never dreamed I'd later go to art school. I hadn't set my heart on it, but I went, and I majored in sculpture. So I suppose that was my start.

In art school, I never dreamed that people would someday pay good money for what my hands had such fun doing. And who knew that in my future I'd be commissioned to create public art in beautiful settings for all to see? Not me. Not in my wildest dreams.

One day, long after art school, walking through a city park, I noticed that people were looking at the bronze sculptures only casually, if at all. They'd glance up at an equestrian memorial to a war hero, high on a massive plinth, and go on their way. I came upon children gathered around a sculpture of a woman holding a cat. They patted the cat and hugged it as though it were real, and their parents smiled, never saying "Don't!" Right then, I saw what I wanted for my art. I wanted my sculptures to be outdoors in parks, where people of all ages could touch and enjoy them.

The best thing about public art is that it's available to everyone, rich or poor, old or young, any time of day. The best thing about *making* public art, for me, has been doing what I love to do. When a sculpture I've created has a strong connection to its site and its subject has deep meaning for the people who commissioned it, I feel I've succeeded.

Much of my better-known public art features animals. The child in all of us

responds to animals, I believe, and the use of animals as a metaphor reaches our innermost depths, whatever our age. Robert McCloskey's picture book *Make Way for Ducklings* was the basis for my sculpture of Mrs. Mallard and her eight ducklings. The story is about caring and protecting one's young. For me, it's about promises kept. I got to know Robert McCloskey. He came to my studio to approve my interpretation of his characters and check on my progress. Later, we flew to Moscow for the installation of Mrs. Mallard and her ducklings there. We kept our professional promises to one another, and his importance to my life as an artist is a story I tell in this book.

Eeyore, my sculpture from another classic of children's literature, speaks to making something out of nothing (the empty honey pot and the broken balloon). *Eeyore* has since been joined by *Winnie the Pooh* and *Piglet*. Each bronze, heartbreakingly, was commissioned to honor the memory of a young person who had died.

Then from Aesop's Fables, the story of "The Tortoise and the Hare" reminds us: *Go at a steady pace. Don't give up. Be yourself.* I needed a lot of tortoise-like perseverance before my sculpture *Tortoise and Hare* found a permanent home in a public square in Boston. I'll never get tired of the smile on that tortoise.

I was very much an adult when I struggled through my first big public art project. Commissions, committees, proposals, and approvals were new hurdles for me, each stage taking months. It took practice to stand before committees – some friendly, some frowning – and convey a work's meaning, to tell what it was made of, how it was made, where it should be placed, and why. It took patience to wait for weeks to find out whether a proposal was accepted or rejected. I can't count the number of rejections – I can, actually. It's dozens and dozens.

Then there were the hours in the studio, times of creative breakthrough or immense frustration. A lot of my work required research into animal anatomy (beaks, tongues, claws, postures, snouts), which to me was endlessly fascinating. I experimented with unfamiliar materials, and I messed up, of course. It's part of the process. But adversity energizes me. I use my irritation and disappointment to move me forward. Perhaps that's an emotional skill. I've needed other skills, too, to troubleshoot, manage paperwork, meet deadlines, and market my work. Some of this has come easily. I had the positive models of my parents to thank. But many skills have resulted from learning "the hard way."

One day, working on the manuscript for this book, I asked myself, Why am I enjoying this so much? Writing, reworking, revising – really? I'm no writer. For so long, I'd dreaded doing a book. Well, it's not so different from making a sculpture: You shape an idea, throw it away, shrug, and start again. Take away some, add. Take away more. You don't mind (not too much) because little by little it gets bet-

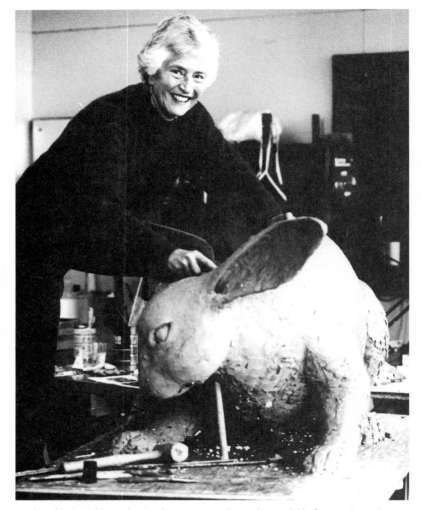

Studio athletics: This is what it takes to create a large clay model before casting in bronze.

ter. You keep at it, you get help, try again, and again, and then it works.

I've been truly fortunate since the day I saw those children petting the bronze cat. I've wanted my art to be available, and it is. I wanted my public art to appeal, and I believe it does. I've wanted people to view my sculptures, touch them, and have a wonderful experience.

And now, through this book I can pass along the stories behind my sculptures and share insights that have kept me going as an artist. I couldn't have done it without the wisdom and the support of others. I'd like to share that, too.

– Nancy Schön

P.S.

At the back of this book, I thank the many people who made my life as a public artist a successful one – an exciting one, full of curiosity, challenges, and the satisfactions of creating art that engages children and the public. Acknowledgment sections tend to glaze the eyes with long lists of names. I've attempted to make it fun to read. See what you think.

Also, much of this book is based on archived materials, but some is based on memory. I've made every effort to keep dates straight and recount the events in order. No inaccuracies of any kind are intentional.

If you know me and you don't see an appreciation in the acknowledgments you think should be there, or if you spot an error, I'd love to hear from you. If you don't know me but enjoy the book – I'd love to hear from you, too.

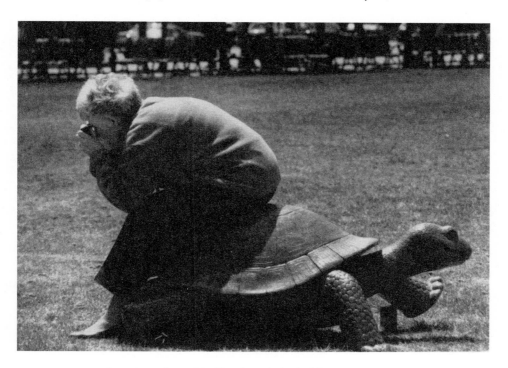

Snapping a photo of the Hare from the back of the Tortoise, 1994.

Our knowledge of shape and form remains, in general,
a mixture of visual and of tactile experiences... A child
learns about roundness from handling a ball far
more than from looking at it.

HENRY MOORE

Without PLAY—without that child still alive in all
of us—we will always be incomplete. And not only
physically, but creatively, intellectually,
and spiritually as well.

GEORGE SHEEHAN

You can't learn to design if you don't do design...
doing it is the only way to learn it.

DONALD SCHÖN

NANCY SCHÖN:

A Life in Public Art

« I »

Nine Bronze Mallards and a Lot to Learn
Make Way for Ducklings

I'M IN MY STUDIO. It's the mid-1980s. The room smells of warm wax, and all around is evidence of work for a series of bronze sculptures – sketches, photocopies, sculpting equipment. An important project is materializing, and for weeks I've thrown myself into it.

At the moment, though, I'm not working I'm pacing. My hair is probably sticking up, and I'm agitated. The project has hit a wall.

Creative work constantly hits walls. Setbacks, and problems to solve, are normal. But this problem isn't aesthetic or technical, and I'm feeling frantic.

That scene says much about my beginnings as a public artist. I'd been a sculptor for many years and liked challenges in the studio. I raised a family and was used to juggling schedules to do my art. Making public art, however, had new dimensions: more people to work with, more challenges outside the studio, and a lot more compromises than I was used to.

Spread out on my work table were the early stages of figuring out a sculpture of Mrs. Mallard and her ducklings from Robert McCloskey's classic children's book, *Make Way for Ducklings*. The "figuring out" was going pretty well. The duck sculptures would be placed where the book is set, in Boston's Public Garden, which is one of the country's much-loved, historic public parks. Importantly to me, the sculpture would be public art children could approach and play on.

All of those prospects were exciting, though they were a long way from being realized.

"I'm worried," I said to a friend on the phone. We were on the ducklings topic, since I can't imagine I had much else on my mind. Out came a flood of concerns: How would Robert McCloskey feel about my taking some of his drawings and turning them into three-dimensional forms? Would he give his permission? Did the publisher of his book have to agree to my doing a sculpture? Who owned the copyright?

It made no sense to keep going until I received McCloskey's approval. I had no address for him. Someone at his publisher would have it, but no one there had re-

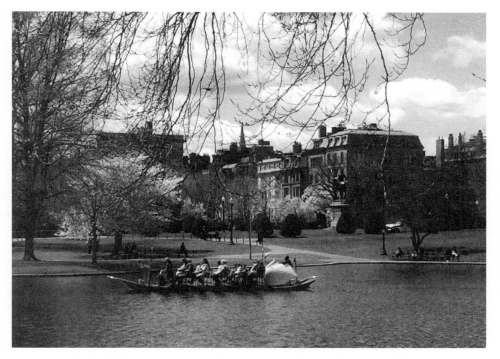

Swan boat on the Lagoon of Boston's Public Garden, the nation's first public botanical garden.

turned phone calls. (This was in the days before commercial email and the internet.)

At last my friend had a chance to speak, and she surprised me. "Oh," she said, "You don't have to worry." She said she and the McCloskeys, Bob and Peggy, were neighbors in Maine. I knew she spent summers in Maine, but on the same patch of island, Little Deer Isle, where Robert McCloskey happened to live? This was wildly improbable. Whether coincidence or luck or Fate, or whatever you want to call it, she offered to "call Bob right up."

Robert McCloskey ("Bob," as many knew him) had written, illustrated, and published, in 1941, his most acclaimed children's book. In the book, the Public Garden in Boston becomes the home for Mr. and Mrs. Mallard and their eight ducklings. ("McCloskey's Classic" on page 19 gives a brief synopsis.)

Forty-plus years later, his book was as popular as ever. Signs were good that key people at Boston's City Hall were not opposed to a public sculpture to honor McCloskey and the book. There'd be hurdles, of course. The first one I hadn't anticipated. I'd charged ahead with enthusiasm but without McCloskey's approval. He had to believe I was the artist most qualified to create the sculpture. I had to prove

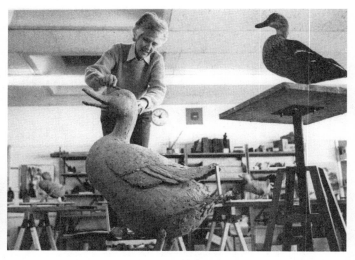
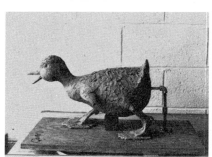
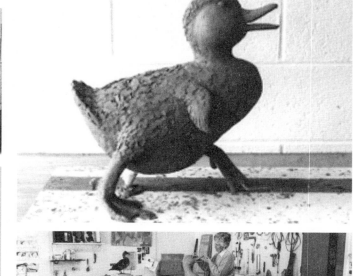
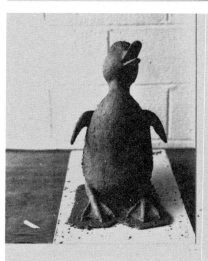

A stuffed mallard from Boston's Museum of Science serves as a model. The ducklings seem small here, but they are actually "giants," up to sixteen inches tall.

to him I could do his work justice. Me, an unknown compared with him. But there was more. The concept I'd been working on wasn't in his book. I wanted the sculpture to be my own design. Would he agree to that?

McCloskey had donated his original drawings to the Print Department of the Boston Public Library. Years back, a mentor had urged me to copy "the masters" – Rembrandt, Rubens, Raphael, Hokusai, and many, many, others – to get inside their heads. If I could do the same with McCloskey's drawings, I felt I could create an accurate translation of his work.

At the library, I sketched from his working drawings. I could see how he saw the anatomical shape of his ducks. In my studio, I visualized what the ducks would look like larger than life. But I needed to make them, individually and as a group, to truly see the sculpture.

I began sculpting a wax maquette, or small model, of the mallards. This showed their poses and how far apart they'd be waddling. For me, an idea is only an idea until it's shaped into a three-dimensional form. Through the process of making a maquette, what will or won't work becomes obvious. What's in your mind might not pan out, and you cannot know until you get started. Many ideas might be tried only to be melted away for another go, when a better idea might show itself. (On page 10, I tell how I make maquettes.)

« « Meeting Robert McCloskey » »

MY LOVELY FRIEND on the phone did speak to Mr. McCloskey. She must have added some superlatives about me and everyone involved because McCloskey said he and his wife would be coming to Boston in a few weeks. He wanted to meet. I was relieved he hadn't rejected the public art idea outright.

When I was close to ready with the wax maquette of the ducks, I called him to set up an exact date and time to show it to him. McCloskey's voice was reassuring. I so much wanted the project to please him.

In person, he was lean, had a high forehead, a crease between his eyebrows, a sculptural chin, and kind eyes. He looked as if he'd just stepped from the pages of one of his books. Knowingly or not, McCloskey had drawn himself and his wife, Peg, into his stories.

I invited them to my house where I had my larger sculptures, which I wanted them to see. They both seemed interested, but I wasn't sure whether they were just being polite. I decided I'd better show them how I envisioned the ducklings. If McCloskey didn't like them, it was all over.

When I presented the maquette, Peg McCloskey's reaction was immediate.

A clay duckling in its Plaster of Paris mold. ("How Bronze
Sculptures Are Made" describes this process.)

"Oh, they're wonderful!" She gently touched the top of Mrs. Mallard's head.

Bob said nothing for a while. This made me uneasy. Then he mentioned size, as in actual size. We discussed it and decided I should make some prototypes – full-sized ducks as they'd be in the final cast sculpture, installed outdoors. But I would make only Mrs. Mallard and three ducklings, not the entire work. The McCloskeys planned to return to Boston in a few weeks. We'd meet again then.

« « Perseverance and Prototypes » »

OVER MY CAREER, during the making of my sculptures, my habit had been to take a long, hard look at a work in progress first thing in the morning. I'd get a fresh perspective. For the ducklings, I made notes for each model along the lines of, "fix the lid on the eye," or "sharpen up the ends of the toenails," or "pull up a feather for bit of action."

Rods and burlap reinforce the mold while the plaster sets.

I worked in an elementary school building that had been converted into artists' studios. My studio was a classroom with windows and running water. The bigger the studio, the bigger the sculpture could be. (In this studio, I sculpted a bronze mural, to be installed on a 10 x 17 foot wall.) The height of Mrs. Mallard, I decided, should be a yard or a little more in height. I often visited the Public Garden to think about scale. The ducklings needed to appear defenseless, but they also needed to be large and sturdy enough for children to pull on them and climb on them. I decided to make them about 16 inches, though they wouldn't each be standing at full height.

Next I constructed an armature for each prototype. An armature is the interior structure you build for the early stages of making a sculpture. It provides a rough shape and, importantly, it gives stability if you build it right. Depending on the figure, clay models can get very heavy and unwieldy because of the many pounds of clay sculpted over the armature. I use Plasticine, an oil-based clay. It's formulated

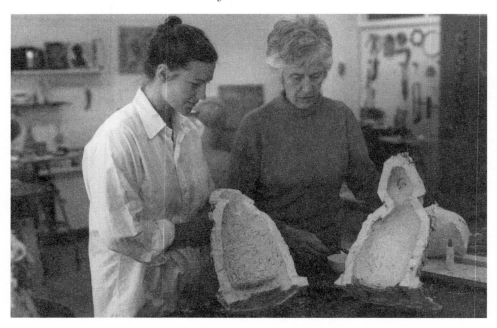

Inspecting, with sculptor Vicky Guerina, the two parts of a plaster mold with its clay duckling removed.

not to dry out. (There are many brands of this type of clay. I'll probably just call it "clay" from now on, to keep it simple. And I've written more about making armatures on page 24.)

When I start a sculpture, I don't foresee the obstacles ahead. I jump in, assuming everything will be all right. As things progress, the problems come. Then I feel totally inadequate and convinced someone will discover I'm a fake and incapable of sculpting such a work. It may even get worse, in that I'll convince myself I can never have another creative thought in my head. Ever.

It's not the right size. That's not a duckling wing. This is a terrible pose. Not enough action. What does a beak look like on the inside?

Perseverance and a bit of stubbornness is needed to put aside doubt and move on. I've also learned that research, thinking, and talking with others helps me find solutions. I try to keep my mind open and not get stuck on one idea or one solution until I'm sure it's the best one. Like every other artist or person who cares about craft and doing things well, whenever I've taken a shortcut, I've usually regretted it.

No shortcuts this time.

As I worked out the prototypes – Mrs. Mallard and only three of the ducklings – I repeated this question to myself, "What might cause a child to fall in love with this duck?" I wondered whether bronze could capture the whimsical feeling of McCloskey's line drawings. Did the models in clay of those little ducks seem vul-

nerable, as they are in McCloskey's book? Had I made them big enough? Safety was critical. Real ducklings, for example, have pointy beaks, which when cast in bronze could hurt. McCloskey had rounded the beaks of his ducklings when he drew them. He'd had real ducklings in his apartment as part of his research for the book, so he must have known their beaks were sharp. I imagined him sketching ways to make the ducklings more appealing to children.

Making four models in so short a time before meeting the McCloskeys weighed on me. The work had been daunting. A painter crossed the hall to say hello and saw how glum I was. She wrote on large paper, "BE STRONG." I still have that sign hanging in my studio.

« « My Collaborator » »

I WAS NOT ALONE on this project. I'd met an urban planner, Suzanne de Monchaux, whose work focused on how children experience city environments. She urged city planners to keep children in mind, to note what children can or cannot reach with their small arms, what urban elements they climb on or jump on, and how they engage with what they come across. I liked her ideas, and she liked mine, of creating interactive bronzes in beautiful environments.

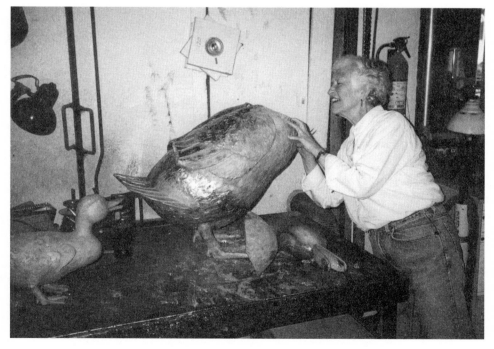

Nancy and the headless Mrs. Mallard after bronze casting.

Before Suzanne and her family moved to Boston, she'd read McCloskey's story to her twin boys, age seven. On their first visit to the Pubic Garden, one of the boys asked, "Mommy, where are the ducks?" This was the seed for what came later when Suzanne called to ask what I thought about making a sculpture of the ducklings.

I must have blurted out, "The Public Garden? It's sacred ground! There's no way." The back and forth between us would be like many in our time of working together.

I probably told her she was "out of her skull."

She insisted, "You're the person to do it."

Me: "I don't have any idea how to do such a thing."

Her: "We'll just have to find out how." I can hear her winning English accent even now.

Suzanne, like many of us, believed McCloskey's book showed how a city, in this case Boston, could be welcoming to children. At a civic event, she had the chance to say so to Boston's mayor at the time, Ray Flynn. He gave her Mary Shannon's name to call for more information. Mary, who was secretary of the Boston Art Commission, was critical to getting us started.

I was lucky to have a partner in Suzanne. Her urban planning experience guided us through proposals and committee meetings – for describing the concept, sharing details, and generating excitement.

She joined me at my studio when the time came to show the prototypes to Bob McCloskey. They were rough, but the action was apparent, and – I hoped – they had more than a vague resemblance to his ducks.

It was a raw February day with snow on the ground. The McCloskeys arrived, and, no surprise, I was apprehensive. One artist interpreting another artist's work is a ticklish situation. Some of Schön had certainly come through, which was good, but to what extent? One can't ever completely hide one's own "hand." I suspect McCloskey was apprehensive as well. He was sensitive enough to realize my position, and I doubt he wanted to hurt my feelings.

Again Peg McCloskey reacted first, enthusiastically. He was more hesitant, observing the ducks, unhurried. His face revealed nothing. Finally, he said, "They might be too large." He was used to them being only inches big, and I was making them feet big. Sculpture in the outdoors always seems much smaller than in the studio, so we decided to take them outside.

Suzanne and I lifted Mrs. Mallard onto a dolly. I made a ramp from some boards in my studio, and we rolled her outside. We placed her and then carried out the three ducklings. As McCloskey mulled over how he felt about the sculptures, two

mothers and three children passed by from a nearby day care. Before we knew it, the children ran quacking to the ducklings and patted their heads. They wanted to sit on them. This was unbelievable luck. We all looked at one another, knowing it was a magical moment. The size was perfect. The whole project would go forward. A few days later Suzanne and I received written endorsement and approval from Mr. McCloskey, and a warm and lasting friendship with the McCloskeys began.

« « Feather-raising Setbacks and Long Waits » »

PUTTING A SCULPTURE in such a highly visited and historic place like the Public Garden was a major undertaking for me, and I felt the pressure of my inexperience. The project needed the sponsorship of the Friends of the Public Garden and the endorsement of committees from the Boston Art Commission, the Landmarks Commission, and the Parks and Recreation Department.

Beginning a Sculpture: Maquettes

Maquette *is a French word that comes from the Italian* macchietta, *which means "sketch." A maquette is a scale model of a larger sculpture. In my work, this is usually my first step. I think with my hands. It's a kind of sketching in three dimensions.*

Much of the hardest work, research, and creativity for a sculpture goes into this stage. Because a maquette is small, it can be modeled quickly and altered quickly, especially if it's made in wax. One can start over – and I do, many times. I angle a drafting lamp over a ten-pound slab of wax in a turkey roasting pan. By adjusting the lamp so the bulb is closer to or away from the wax, I can heat the wax to soften it, or cool it to firm it up, according to my needs. (Some sculptors put their wax in a double boiler on a stove, thus keeping the entire pot of wax warm.) I scoop or scrape off wax using dental tools and other sculpting tools. I also use my hands to begin a form.

When I'm satisfied with a basic pose, I refine the details.

To me there's something essential about expressing a form directly. It's the way I make decisions and make changes.

After I've completed the wax model, I brush it with bronzing powder. The more a piece looks like bronze, the more a client or committee is likely to accept the concept. I also mount the maquette on a marble base, to which I attach hardware for a 360-degree rotation. By making all sides visible, there's less chance for lingering questions.

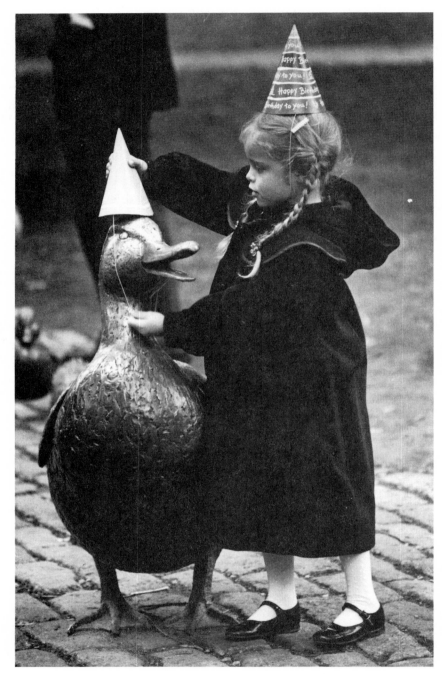

Beth Lynch enjoys the ducks' first birthday party, October 4, 1988

Commissions do much good for the life of a city, for the health and stewardship of its green spaces, for example, and more. They are often composed of lay people who work on a pro bono basis. They meet on an as-needed basis depending on what business is at hand.

Suzanne and I knew we would face these committees over many months to seek approvals. We had to put together presentations and determine a budget for all phases of casting and installing the sculpture. We would also have to raise funds. These were all formidable tasks. Not only do the stages of making of a public art sculpture take long stretches of time, but coordinating meetings and preparing paperwork do, too. The whole of a project can take years. In the early days, I didn't know this; I just kept working at it.

In the midst of our preparation, a powerful developer with huge financial resources contacted McCloskey. The developer was building a large complex of condominiums in downtown Boston and wanted to put Mrs. Mallard and her ducklings in the complex's courtyard.

What? How did he find out? What did this mean?

Our hope for the Public Garden site was suddenly doomed. I must have paced for days between all the phone calls. Once, speaking by phone with McCloskey, I asked, "What do we do now, coach?" He told me he'd suggested to the developer that hundreds of crying children with dripping ice cream cones traipsing through the courtyard certainly wouldn't be ideal. This endeared me to McCloskey. I knew he abhorred the idea of T-shirts printed with his ducks. He'd also stopped a well-known company from producing the ducklings as stuffed toys because the manufacturers used a fabric that might be toxic.

McCloskey had made it clear the ducks belonged in the Public Garden. He showed what a principled man he was. Money was not his god.

The Friends of the Public Garden scheduled our first meeting. This group had the power to accept or reject our project, despite McCloskey's approval. My studio was chosen for the meeting place. Before they came, I had to finish the five remaining ducklings, making their armatures and layering on the clay, and refine them all. My rendering needed to be of the highest quality.

I had a tough time getting Mrs. Mallard to turn her head and look up. I'd made and remade this pose and finally got it right. However, one June morning after a hot spell, I walked into my studio and found half of Mrs. Mallard's rear end on the floor! The heat had softened the clay over the armature, and the heavy tail pulled completely away from the rest of the body. Thank heavens it wasn't the head and neck that fell off.

I had to remake the armature quickly and put Mrs. Mallard back together. My

nerves were wrecked. Though the Friends' appointment turned out to be on a hot day, I decided to risk it and position the ducks outside, knowing they'd look better in a natural environment. The sculpture looked good, I believed, but I had visions of Mrs. Mallard's tail falling off again.

The Friends committee included Henry Lee, their president; the Art Editor of the Boston Globe; the Curator of Decorative Arts from the Museum of Fine Arts; and several others from different backgrounds. They arrived one by one, asked a few questions, spoke among themselves, and looked around my studio, which I had cleaned and polished to perfection. They had some cold juice and cookies, thanked me politely, and left. I had absolutely no idea what they were thinking. A week went by and I didn't hear anything. As each day passed, I became more anxious. Finally, on the excuse of calling Mr. Lee about something else, I asked him what the committee had decided about the ducklings. In a most casual, almost throw-away sentence, he said, "Oh, they loved them, and they were excited about you." They believed I wasn't a temperamental artist.

A month or so later, a letter established the Friends of the Public Garden as our official sponsor. Another hurdle overcome, a most important one.

In September 1986, Suzanne and I were to make a presentation in front of the Boston Art Commission. By then, the duckling models were more developed and heavier. We took a taxi. The driver thought we were loony, with our big clay ducklings, the wax maquette, and large presentation boards. In shifts, we carried it all into the lobby of Boston City Hall, no small feat, crammed everything into an elevator, and eventually located the meeting room. There we were, with the ducks on clay-encrusted sculpture stands, and a half-dozen people attending. Our presentation seemed to go well, but one never knew, and the pressure I felt was enormous. A negative response to any one of our presentations could end the project.

Several weeks later, we finally got word from the commission that our project had been accepted unanimously. They stipulated, however, that they wanted to follow the project as it moved forward. Fair enough. We had cleared another hurdle.

The Landmarks Commission asked us to meet with them in October. We went through our usual presentation carrying the ducks and the boards with us. After finding out way through maze-like corridors, we arrived at the appointed time, and waited. A half hour later, two rather indifferent-seeming people finally showed up. They turned out to be our committee. In due course, we got the green flag from them, too.

« « Early Steps to Installation » »

SUZANNE AND I had been considering where exactly to site the duckling family in the Public Garden. We met at the Charles Street gate, which the ducks passed through in McCloskey's book. There were three paths from there. The middle one led to the pond and the Public Garden's famous swan boats. Along this slightly curving path, we noticed two magnificent trees, one an oak, the other a maple, far enough apart and in exactly the right place to frame the ducks. We could envision Mrs. Mallard and her family marching behind her in a line to meet Mr. Mallard on the island. It was the right spot.

Susanne handled getting a site plan for our meeting with the Parks and Recreation Department. Finally, in May 1987, she and I stood at the proposed site with the Parks and Recreation representatives. They accepted our presentation with the proviso that they approve the installation of the sculpture – they didn't want the installation to interfere with the roots of any trees in the vicinity. Hence, the installation had to be conducted and overseen by expert landscape people.

We needed a company with broad experience in masonry work and engineering expertise. Each duck would have to be positioned exactly as conceived – relating to the duck on each side of it. Stainless steel rods would run through the feet and attach to stainless steel plates held in place with concrete footings. (The block of

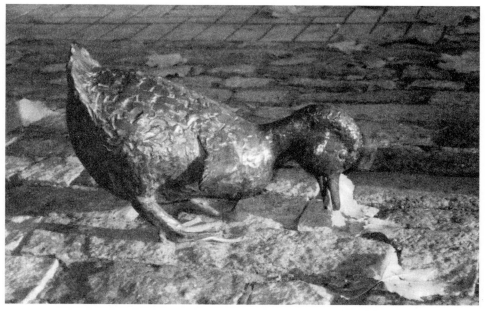

Kack snacking on autumn leaves. Children feed the ducklings all kinds of things.

concrete – its size and weight – is determined by the size of the sculpture it must support.) Footings for the ducklings needed to sit below the "frost line," so that heaving of the ground upward when it freezes would not affect the sculptures. And on top of the groundwork, we wanted cobblestones. These had to be laid to fit under each duck as it was installed. We'd need more than 500 cobblestones.

Ollie Capizzi, founder and head of a landscaping firm, became our contractor of choice. As it turned out, Ollie had done a great deal of work in the Public Garden and was highly regarded by both the Parks Department and The Friends. Yes, he could ensure the trees' roots would not be harmed. He told me he learned all he knew about the landscaping business from my father. What a coincidence! My father, Harry Quint, had been a Boston retail florist and had greenhouses and land west of the city for a landscaping nursery.

About the cobblestones? Ollie bragged that he'd have the ducks on old Boston cobblestones, marked and colored by iron carriage wheels from another century.

« « Getting to Final » »

IN THE BACKGROUND, while meetings and anxious periods of waiting took place, Suzanne and I raised money – no easy task – or I was in my studio preparing nine clay figures for the bronze casting and finishing. (No easy task, either.)

First about funding. I was naïve, and Suzanne was new to the city. Without funding, there'd be no sculpture or long-term maintenance. Suzanne applied to foundations for grants that supported community activities. Money was raised, but it was not enough.

Despair descended until a remarkable thing happened. Nancy Coolidge, Executive Director of the Society for the Preservation of New England Antiquities (SPNEA), heard about the project from a friend of mine. Nancy and her colleagues offered a brilliant idea: Ask people to adopt a duck. The Adopt-a-Duck campaign, at $5,000 per duckling, raised over half the funds we needed. We would still have to raise money, but with this influx of funds, we could go forward.

Now for the casting. I invited Robert McCloskey to the foundry. I would not cast the ducklings until he'd seen them all together as they would be for the final sculpture. What he saw of the foundry's work fascinated him, though the complete casting process takes many days. Molding and lost-wax bronze casting has many steps, and some might say the work is grueling. I've chosen this kind of casting because the results speak to the ages. Bronze sculptures are works that last for centuries.

Before we got to the foundry, though, I had nine molds to make for the nine

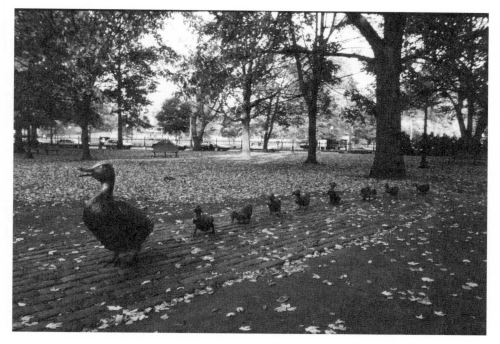

Mrs. Mallard proudly leads her splendid ducklings across the Public Garden to the Lagoon, just as she did in Robert McCloskey's book.

clay models, to create a plaster cast of each duck. Clay doesn't last in the foundry process. Having a plaster model is like having insurance. It's a time-consuming process, making the plaster replicas. (There's more about this process in the section beginning on page 91.) A fellow sculptor, Vicky Guerina, helped me. We stored them and took the clay models to the foundry.

First we cut away each set of clay wings from the models and organized them so we'd know which duck they belonged to. We did the same for the bills.

The foundry team coated a polyurethane rubber layer over each clay model. Here's a summary of the process: When the rubber layer sets, it's covered with plaster of Paris to keep the rubber in place. The clay is removed from the rubber, and the rubber mold is cleaned. Then a quarter-inch layer of hot wax is painted into it. The rubber and wax are then carefully separated, and the wax becomes the positive for the sculpture. This wax form is dipped into a ceramic slurry several times (and has to dry between each dip) to create a ceramic shell. A ceramic mold can withstand high heat. When the ceramic mold is placed in a heated kiln, the heat disintegrates the wax, which is "lost." Then molten bronze is poured into the empty ceramic mold. When the metal is cool, the ceramic is chipped away. (The foundry process is shown on page 91.)

The overall form usually has to be cast in pieces, and the cast bronze pieces are then welded together. For the ducklings, the wings and bills were cast separately and welded onto the ducks. After the welding, the bronze surface is worked by hand, to ensure the surfaces match what I had originally sculpted.

Because the feet and legs of the ducks would be fragile, they needed to be made of resin. Which resins were the hardest and most durable? Vicky and I talked with boat builders in Boston to find out. We made molds for the feet and legs, just like molds for the bodies, wings, and bills, in case we needed to reproduce the ducks later. We did – almost immediately. Hours after the entire sculpture was installed, Quack was stolen. (An unwelcome shock. Stolen ducks are another story, which I tell in the last chapter.) We had only a few days before the dedication ceremony to recast Quack and redo the installation.

This crisis, and the white-knuckle rushing around to solve it, might have been enough to convince me to reconsider public art. But accolades made up for it.

On the brisk, rainy afternoon of October 4, 1987, the sculpture was dedicated. The date coincided with the 150th anniversary of the Public Garden. The plaque for the sculptures states:

> *This sculpture has been placed here as a tribute to Robert McCloskey*
> *whose story "Make Way for Ducklings" has made the Boston Public*
> *Garden familiar to children throughout the world.*

That wet day – a perfect day for ducks – was extraordinary for me. The McCloskeys were with us. Children, including my grandchildren, played on the ducks, giggling and having so much fun. I was thrilled to pieces. But it was more than that. I was proud of the sculpture. I'd accomplished what I set out to do and had somehow gotten into Robert McCloskey's head, understanding how to capture his ducks and also make them mine. The sculpture was my work, but deeply respectful of his.

Later, Robert Campbell wrote in the *Boston Globe Magazine* on June 5, 2005: "There are a dozen statues in the Boston Public Garden, mostly of dignified early Americans. George Washington's is the biggest, but the best loved is the one by sculptor Nancy Schön of the feathered family from Robert McCloskey's children's book *Make Way for Ducklings*."

In so many ways this project changed my life. McCloskey liked my sculpture, which was the highest compliment. Thanks to his story and outstanding illustrations, and thanks to his generosity in accepting my work, the sculpture continues to give pleasure to so many.

Robert McCloskey and fans of *Make Way for Ducklings* in 1987 at the sculpture's dedication ceremony. Translated into many languages, his book has sold millions of copies since 1941.

McCloskey's Classic

In case you haven't read Make Way for Ducklings *recently, the story goes like this: Mr. and Mrs. Mallard are flying about above Boston in search of just the right place to start a family. They're tired. They see the Public Garden, which has a pond, and they decide to go there to take a break and find food. All's well until a young cyclist nearly mows them down. Not the right place for babies, Mrs. Mallard declares. So she and Mr. Mallard fly over other areas and choose an island in the nearby Charles River. They settle in and hatch their eight ducklings. One day Mr. Mallard tells Mrs. Mallard to meet him in the Public Garden in a week. Until then, Mrs. Mallard gives her eight ducklings swimming lessons, marches them in a row, and teaches them how to dodge bicycles and cars. The week passes. She and Jack, Kack, Lack, Mack, Nack, Ouack, Pack, and Quack waddle away from the river and attempt to cross a street. Traffic jam! Michael, the friendly police officer, arrives and stops traffic so Mrs. Mallard and her ducklings can safely cross. He calls headquarters for more officers to stop cars and make way for the ducks all the way to the Public Garden. The ducklings are admired on their walk, Mrs. Mallard is proud, and finally, the whole family is together.*

« 2 »

The Seven Year Race
Tortoise and Hare

IT'S 1988, MID-APRIL, Boston Marathon day. I'm by the race route with hundreds of others, shouting encouragement to runners struggling up Heartbreak Hill. The hill is a notorious test of will that begins its rise about twenty miles from the starting line. By then runners' faces are strained, their legs are exhausted, and their feet hurt. I'm admiring them, feeling their sense of determination and accomplishment. I'm in the same spot where my brother, sister, and I as little kids leaned out to put orange slices and cups of water into the hands of sweating runners as they huffed past.

During all the noise and cheering, the town of Hopkinton crosses my mind. I think: Boston always gets a lot of attention for the race, but not Hopkinton, where the race begins. Thousands descend on the small town at sun-up and leave behind a mountain of trash. It marks the start of the oldest foot race in the United States. Wouldn't Hopkinton like to be honored?

« « A New Project » »

HONESTLY, I'M NOT SURE it was that exact moment, being awhile ago, and I don't keep a diary, but that marathon gave me a strong inkling for a new public art project. The ducklings sculpture had been installed. Winter snows had melted. Spring blooms and green parks would soon be in sight. I drove out to Hopkinton to explore. I do remember asking a young man, "Where's the starting line for the marathon?" He directed me to a dirty, peeling strip of paint across Main Street. There were no other indications of the event around town.

In those days, the late 1980s, runners numbered in the six thousands. Add the runners to the number of spectators in town on race day, and the total probably added up to more than Hopkinton's population at that time. Crowds descended for a few hours, ruined the grass, overflowed the trash bins, used the facilities, and left. (Today, the starting line is brightly painted, helicopters hover, and more than 30,000 runners are bused in.)

My Hopkinton visit convinced me a public sculpture for the town's role in the race made sense. But what concept would best acknowledge the runners, who

were people of all ages from all over the country and the world? The breathtaking wheelchair racers had begun taking part. Some runners competed for time, and others ran or walked just for the challenge of finishing. What would be a serious and meaningful metaphor for the marathon? What might also appeal to children?

Depicting the legend of the first marathon wouldn't work. The story goes that a Greek messenger in 490 B.C. ran from Marathon to Athens, a distance of just over 26 miles. His task was to deliver military news, and he died from exhaustion. Another ancient Greek connection came to mind, the race between the tortoise and the hare in the fable by Aesop. The more I thought about it, that story was a good fit. ("The Fable" on page 29 is one version.) I envisioned a large bronze tortoise and hare on the Hopkinton village green near the starting line.

« « The Poses » »

FOR THIS PROJECT, I thought having live animals in my studio for on-the-spot reference could not only help me but be a lot of fun. The differences between rabbits and hares, and between turtles and tortoises, I'd adjust in the sculpting – the poses were more important.

At a pet store I found a short-haired bunny and named her Cutie Pie. She was so cute, some days I spent more time playing with her than using her as a model. The turtle I chose resembled a tortoise, though he was very small. Anyway, I liked him, particularly the markings on his shell.

The hare's pose needed to show it had stopped racing or was slowing down. After trying out a variety of ideas in wax, my favorite turned out to be the hare nonchalantly scratching its ear. A hard one, though – I could find no photos showing it, and for good reason. A back-leg-scratch happens so quickly. So I devised a trick. With a tiny paint brush, I tickled Cutie Pie's ear. She'd scratch at once. I had to watch carefully, but over time, the lifted foot and tilted head translated well into a wax model.

When I was pretty sure I had what I wanted in wax for both animals, I got in touch with Hopkinton's Board of Selectmen.

Working in wax at a smaller scale allows for quicker decision-making.

The Tortoise in its wire-and-styrofoam stage. An armature like this gives structure and stability to a clay model.

« « A Pitch, a Sponsor, an Advocate » »

AT THE JUNE 1990 Selectmen meeting, I described my idea – a sculpture for the Hopkinton Common as a tribute to the Boston Marathon and its participants. I gave the group a preliminary proposal that included an estimated budget. No decisions are made at such presentations, but I got a call later from the chairperson. She suggested that the Boston Athletic Association (BAA) might want to sponsor the project and help with fund-raising. She added that many in Hopkinton would be willing to help. (Not every public art project needs a sponsor, but sponsorship is one way to help with financing.)

When I talked with Guy Morse, the Race Director of the Boston Athletic Association, he said the BAA sought special annual projects leading up to the 100th running of the race in 1996. The sculpture of the fable would be ideal for 1994. (Johnny Kelley, known for his wins and many runs, would be celebrated in 1993, for example; the 100th anniversary would tie to the Olympics in Atlanta.) On October 30, 1991, he wrote a letter of intent to sponsor the sculpture. The BAA's endorsement included fund-raising efforts. Good news. But you can see how long public art projects can take. It's a reason to have multiple projects (of any kind) going simultaneously.

Time passed. Not enough funds or commitments were coming in. Corporations, it seemed, weren't interested in donating money to a small town like Hopkinton, which had national visibility only one day a year. Although getting a sculpture placed in Hopkinton looked hopeless, people had been enthusiastic about the concept. I did not give up. I'd already "scaled up" the dimensions from the wax

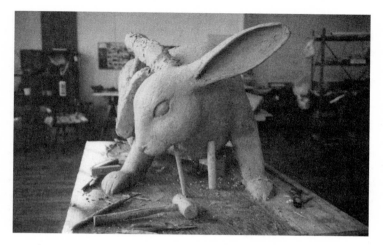

Clay model in progress. When finally cast in bronze, this hare will attend
concerts in the country's finest concert halls.

maquette and begun constructing stable, interior frames – the armatures – for the
actual-size models of the animals, which would be in clay. (See "Building Arma-
tures," page 24.)

I finished an armature for each animal, and began sculpting. By then, it was early
1993. I'd moved my studio from the elementary school to an old rug factory build-
ing. This new space was larger, a thousand square feet with a high ceiling. The
factory space had needed to be transformed, and I collaborated with others to turn
it into a decent place for serious artists to work. There were fifteen of us. Open
Studios was coming up when hundreds of art lovers would visit. I hoped my large
models of the tortoise and hare might generate excitement for the project.

Sure enough, here came Stella Trafford and Phebe Goodman. There is much
to say about these amazing urban activists for Boston's green spaces. For decades,
Trafford oversaw the health and variety of hundreds of trees on the linear park
called the Commonwealth Avenue Mall, which spanned eight city blocks. She
was behind the renovation of Copley Square, now a city landmark. She founded
the advocacy group Friends of Copley Square, and Goodman was the group's
executive director. When we talked about the fable and models in my studio, it
made sense that the Friends of Copley Square would want the sculpture in Copley
Square, at the *end* of the race. Trafford said the sculpture would give the square
some much needed humanity, some whimsy and fun.

Trafford's participation renewed the interest of the Boston Athletic Association.
Now I had two sponsors, the BAA and Friends of Copley Square, and a new poten-
tial site. I felt as if those two critters were going to have their race after all.

I knew from the ducklings that a Boston public art project needed the approval

Building Armatures

An armature is an interior support structure in the basic shape of a sculpture to be made and cast in bronze. It needs to be sturdy but flexible, in that a sculptor isn't confined to an exact shape. Parts need to be easy to adapt as a work progresses, and yet support the weight of the clay used for sculpting. For a large work, that weight can be considerable.

I start with plumbing pipes, which are relatively inexpensive and come in a variety of angles, lengths, diameters, and material. They can be assembled somewhat like Tinker Toys. Cast iron plumbing pipes work for me. The ends screw together, and cast iron is surprisingly soft. You can cut into it with a hacksaw. I make cuts and then pound the pipes into appropriate shapes. In fashioning the configuration, I include a stabilizing central pipe, which will be mounted and secured onto a wooden base. Pipes can be reused. Later, after a sculpture is cast, I take apart armatures and store the pipes.

Over the pipe "skeleton," I use aluminum wire to attach pieces of Styrofoam – it's lightweight and inexpensive. I start with large pieces and cut them down to create the sculpture's rough shape or body. Over this, I'll begin sculpting with clay. However, Styrofoam and Plasticine (the oil-based clay that doesn't dry) repel one another. A between-layer is needed for clay to stick to.

If you've ever repaired walls in an older house, you might know about wood lath and plaster. Lathing, or thin strips of rough wood (sometimes covered with wire mesh), is nailed to house supports before layers of plaster are applied. Plaster will stick to this wood-and-mesh substructure. At the hardware store, I found something similar – a roll of Gutter Guard mesh screen, which is used to protect gutters from fallen leaves and pine needles. (There are other names for this type of screening. Gutter Guard is what pops to mind.) I wrap the mesh around the Styrofoam and screw it into place with blue board screws. (Blue board is a kind of drywall). Clay will stick to the mesh.

The wooden base dimensions need to be large enough for the entire sculpture to fit on its surface. It needs to be thick enough to be sturdy. A flat metal plate is added, which has a threaded hole. The central pipe (mentioned early) that supports the armature's overall weight is screwed into the metal plate for extra stability.

Armature building goes more quickly with shop tools, such as a drill press and table saw. No matter how practiced you are, sometimes you have to undo parts that don't work – perhaps they are too large or too small. And sometimes you have to redo the whole thing. Armature building takes patience and muscle, and learning from trial and a lot of error. It helps to develop a sense of proportion and an innate understanding of weight, balance, and counterweight – a kind of gut engineering, I guess. The whole time you're at it, you've got the vision of the final sculpture in your head.

of the Arts Commission and the Landmarks Commission. Once they approved, the Parks and Recreation Department would be next. Trafford and Goodman helped me with proposals and helped shepherd me through a maze of bureaucracy. Without them, the *Tortoise and Hare* would never have made it to Copley Square.

But the sculpture wasn't there yet. Funding needs had not gone away.

In August 1993, Trafford wrote to the BAA, "If we are serious about putting the *Tortoise and Hare* into Copley Square next spring, we had better get off our cotton-tail." In September, Guy Morse generously sent out another letter soliciting contributions from runners and corporate sponsors of the race. With the encouragement of Trafford and Goodman, with the approval of the commissions, with the BAA's plan to install it for celebrating the 1994 marathon, I got seriously to work finishing the sculptures in clay. We'd received a grant from a foundation dedicated to "the enhancement of the physical appearance of the city of Boston" – wonderful! – but it did not begin to cover the full expense. Still, I'd promised everyone the sculptures would be ready on time. I needed every day of the seven months I had remaining, to finish sculpting and to cast the animals. As the deadline approached, I spoke to the BAA to say the clay sculptures had to go to the foundry to ensure the casting would happen on time. I was assured the money would be forthcoming.

New England Sculpture Service, the foundry, cast them in silicone bronze, and the animals had a beautiful patina finish. The installation team was ready, but we had no go-ahead. On pins and needles over the funding, I called and called for days, but got no explanation nor response from the BAA.

« « Spur of the Moment Surprise » »

WHILE I WAITED TO HEAR from the BAA, a friend let me know about a new composition called *The Tortoise and the Hare* by Stephen Simon, Music Director of the Washington Chamber Symphony. The piece, music and spoken narration, would be performed at the Kennedy Center Concert Hall in D.C. as part of a series of children's concerts. Perhaps the bronzes could make an appearance at the world premiere of this work, where children could see them before the concert, at intermission, and afterward? Brilliant friend! If the sculptures weren't going to be installed for the marathon coming up, why not do this?

No shrinking violet, here, I called Stephen Simon. He asked whether I could get the sculptures to the Kennedy Center. I would sure try. There wasn't much time, but Jim Montgomery, who cast them at the foundry, thought the whole idea was "cool." Of course I did, too. So he got the 400-pound sculptures loaded into his truck, and we drove them south. It was nutty but a great diversion from my

frustration with the BAA.

Kennedy Center workers pushing the sculptures on dollies got them safely into the spacious lobby. Before the concert I watched as children saw the sculptures, greeted them, hugged their heads, and sat on them, especially on the tortoise's back. Then in the concert hall, before Stephen Simon raised his baton, he told the audience about the travels of the *Tortoise and Hare* from Boston to Washington, and asked me to stand. Some 2,000 people applauded and whistled. What an exhilarating experience and confirmation of my work.

« « In and Out of the Garage » »

THE TORTOISE AND HARE CAME home from Washington, D.C. The April 18, 1994 marathon was run, but my public artwork was not a part of the celebration. The two sculptures had to go to my garage and wait.

Left with such a huge debt for the casting, I applied for a grant from the Edward Ingersoll Browne Fund. Its grants help pay for public art on city property, the idea being that art should be for all the people and not just housed in museums or private collections. This was — and is — my belief as well.

Also, to help recoup my costs, I cast a small run of the maquette to sell to corporate and private donors. I also designed tortoises and hares to wear as jewelry, and designed T-shirts and sweatshirts, which members of the Friends of Copley Square hawked with me in the square during special events. Thank heavens for the Friends of Copley Square. They stuck by me, and together we defrayed some of my direct expenses.

Then out of the garage! The *Tortoise and Hare* were invited to be part of Mayfest, an annual event in Copley Square. A crane lowered them in place on the square's Great Lawn. Immediately, kids came over to play on them, and not only children. Adults sat on them to have their pictures taken. I had more confirmation that people really liked them and responded to them. All the time and energy seemed not to have been wasted. I felt very lucky.

But back to my garage the sculptures had to go.

They'd had a temporary moment on the Great Lawn, but they could not be installed there. Another truck ride for the tortoise and hare, more crane lifts from place to place in Copley Square to see where they might go. Justine Liff — who was the first female commissioner of the Parks and Recreation Department, which oversees a long list of public parks, trees, fountains, squares — tried to explain the numerous reasons why this spot, or that, wouldn't work. The lawn could have no sculptures on it, period. Things got a little testy. We couldn't decide on their site,

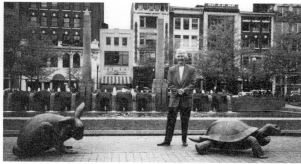

Moving the 400-pound Tortoise requires a crane. Nancy with the *Tortoise and Hare* in front of the fountain in Copley Square.

and the sculptures returned to my garage.

Phone calls, meetings, memos, discussions, and letters — where to place the sculptures? I think it was a bit like what goes on with Congress. A compromise had to be reached. Finally, Kenneth Crasco, the head landscape architect of the Parks Department came up with a site that made us all wonder why we hadn't thought of it before. They should race in front of Copley Square's fountain. As is often the case, the perfect place was perfectly obvious. However, the paving stones at the fountain, which had a definite pattern, were no longer available. To install the bronzes, large holes had to be dug for concrete footings (which stabilize the sculptures). The stones would have to be taken out of the pavement for digging the holes, and then put back without a single one being broken or damaged.

Before that tricky installation, these adventurous animals had yet another move. The Boston Symphony's new Pops conductor, Keith Lockhart, was scheduled to conduct his first major Pops Family Concert. This opportunity, like the one in Washington, combined art and music for children and families, but the concert date was only days before the final installation and dedication of the *Tortoise and Hare*. Well, short timing wasn't going to stop me. I got on the phone. The Boston Symphony agreed to put Stephen Simon's piece on the program. The sculptures left my garage for historic Symphony Hall. Richard Dyer (my favorite music critic) wrote about the concert in the *Boston Globe*, May 15, 1995:

"[I]t was a nice touch to bring Nancy Schön's tortoise and hare sculptures for the Boston Marathon finish line to complement Livingston Taylor's narration of the fable. Before the concert and at intermission children were lining up to climb on the hare and stand on the tortoise's tail."

« « Finally! May 19, 1995 » »

THE TORTOISE AND HARE WERE at last installed in front of the fountain in their

permanent home. For the dedication, I prepared a brief speech. I thanked those who'd made the sculpture possible, who had donated and advocated and supported a sculpture created by a woman. I thanked the foundry and the installation team, and agreed that public art could bring "humanity" and joy to anyone and everyone.

I never heard a word from The Boston Athletic Association, which did not donate one single cent to the sculpture. Who knows why? They were involved with the Johnny Kelley bronze sculpture installed in 1993 at the base of Heartbreak Hill. They seemed to have a grand idea for the marathon's 100th anniversary. The *Boston Globe* reported neighborhood opposition to the BAA's proposed 25-foot arch, to be supported by eight columns, with a "a circular medallion depicting the marathon route in eight colors of granite, along with the names of the race winners." The budget was $400K. But various groups – the stewards of Copley Square – defeated the proposal.

The day of the dedication was gray and slightly rainy. Many children, including my eight grandchildren, came and played with the sculptures. Aesop's "The Tortoise and the Hare" was read aloud by Craig Hill, who had published a book of his translations of the fables. The long-time mayor of Boston, Thomas Menino, looked out at the sea of children and said, apropos of the slow-and-steady tortoise, "You can achieve any goal in your life; you can always get ahead." He handed scissors to my granddaughter Jackie, and at the count of "one, two, three," she cut the green satin ribbon. The crowd cheered.

In my studio years before, I had put a smile on the tortoise's face. Now, as young and old walked by, I saw them smiling back.

« « On to Crystal Bridges » »

MOVE AHEAD TO SEPTEMBER 2007, many years after the Copley Square installation. The voice on the phone belonged to Chris Crosman, the founding curator of the Crystal Bridges Museum of American Art. Crosman said Crystal Bridges was interested in acquiring one of my sculptures. He was in Boston from Bentonville, Arkansas, where Alice Walton of Walmart fortune had opened the new museum.

Chris and I met at my studio, and his enthusiasm about art made the visit memorable. The more he told me about Crystal Bridges, about how the collection focused on "outstanding American artists" over our country's history, the more I felt humbled to be part of it. But then, he told me the sculpture the museum wanted – *Make Way for Ducklings*. I moaned. How could I say no to a chance to be in this museum?

I explained, as I had to so many others, that I'd promised Robert McCloskey I would not reproduce the ducklings sculpture. McCloskey had believed it belonged

Here is an excerpt from Jean de La Fontaine's version of the fable, translated by Craig Hill:

To hurry isn't enough: one must depart on time.
The tortoise and the hare will serve to make this plain.
"Let's bet," the tortoise says. "I'll lay you odds, that I'm
The first to yonder spot!" "The first? Are you insane?" …
Our hare has only four of his best leaps to go,
Like those he makes that leave the dogs behind from here
To kingdom come each time they flush him out — and then
They're off across the fields again.
But having, I mean to say, some time to spare — to browse,
Or sniff the shifting winds, or close his eyes and drowse,
The hare sits back and lets the tortoise go.
Slowpoke is off and running hard!
First inch by inch, then yard by yard,
Like an old senator — full-speed-ahead-dead-slow!
Meanwhile, despising such an easy race to win,
The hare does every sort of thing — except begin.
He stretches, scratches, takes some time to ruminate,
Planning to show how fast he can accelerate.
Thus when he sees the tortoise, finally, about
To hit the tape, though like a rocket he shoots out,
He finds himself, alas, a hare a hair too late!
The tortoise gets there first and wins the day.

"Well, then," the tortoise pants, "I guess we'd have to say
That I was right and you were wrong.
What use to you was all your speed?
I've beaten you! And how, indeed,
Would you have run if you'd carried your house along?"

VI.10
From The Complete Fables of La Fontaine: A New Translation in Verse,
 Arcade Publishing, NY.
Craig Hill recited the fable in verse at the dedication ceremony for the sculpture in Copley Square.

in Boston where the book took place. (The Moscow installation was the one exception McCloskey made. "How the Ducklings Got to Moscow" tells the story, beginning on page 62. McCloskey died in 2003, and I've kept my word to him, to this day.)

Chris left my studio with a good idea of my work. I heard from him again in late November. He said the museum now had an interest in the *Tortoise and Hare*, which might work well in a "densely wooded setting with a stream and small ponds." Many months later, Crystal Bridges formally selected *Tortoise and Hare*. With the museum's letter of approval, I called the foundry and we got started on the reproduction.

The original molds for the sculptures had been made in twenty-two pieces. Those twenty-two rubber molds I'd kept in storage. The foundry made new wax pieces from them. Before we cast the wax in metal, there was an important step – chasing. The term comes from the French word meaning "push back." When a piece is cast is wax and bronze, it will have imperfections – pits, bubbles, and seams, for example. Handwork is needed, using a variety of chasing tools. This can take weeks. I transported the wax pieces from the foundry to my studio and chased them to remove any flaws. The foundry and I repeated the chasing process on the bronze surfaces of the figures once they were cast.

Summer 2009, the sculptures were cast, blanket-wrapped, and shipped to the Crystal Bridges Museum. I received final payment, and then all was quiet.

It turns out the construction of the museum building was underway. After that, the grounds would be designed. The museum wanted a "clearer feel for the trails and approaches to the museum" before deciding on a site for the *Tortoise and Hare*.

The museum's opening happened in November 2011. By then, Chris had left. In 2012, which seemed entirely too long to wait for communication, I got in touch with the executive director. He said the museum had an unusual, high-profile idea for the sculpture's permanent placement, but it required approval of the City of Bentonville. I was intrigued.

His office sent photos of actual-size cardboard facsimiles of the animals to show me where the sculptures would be sited. Tortoise was right at the entrance and Hare was across the road. The museum's brochure states: "This pair of competitors from Aesop's famous race seem to be guiding guests to Crystal Bridges via the Art Trail. Nancy Schön is well known for her whimsical, engaging sculpture featuring animals – often from well-loved works of children's literature..."

Thankfully, the "race" to Crystal Bridges finish line took less time than the seven years for Copley Square. Both the Copley Square and Crystal Bridges installations are sources of great pride for me. No longer in a garage or in a storage warehouse, the two bronzes are in sight and within reach of "children of all ages."

Curators at the Crystal Bridges Museum made cardboard mock-ups to help find a great location for the sculptures.

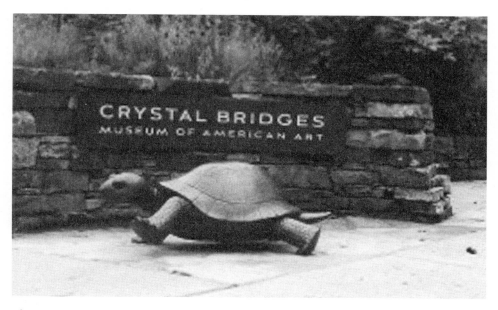

The Tortoise "runs" toward the museum's front gate, while the laid-back Hare lags behind across the road.

« 3 »

Research, Raccoons, Prairie Dogs
And Travels with a Special Giraffe

WHILE THE *TORTOISE AND HARE* were hanging out in my garage or going to concerts, I began work on a public art commission for a small city, Belle Meade, which is part of Nashville. I'd gotten a call from Joseph Ledbetter in early 1994 to say he wanted to put a replica of *Make Way for Ducklings* on the grass median of Belle Meade Boulevard at the Children's Bridge (near Tyne Boulevard). The sculpture would be a memorial for a dear friend of his who had died unexpectedly.

These kinds of requests were fairly frequent in the years following the ducklings. I explained to Mr. Ledbetter that the ducks weren't an option because of my promise to Robert McCloskey. But I said I'd be happy to come up with another idea.

Tennessee. For no particular reason, my first thought was of the late Tennessee senator, Estes Kefauver. My husband and I had lived in Washington, D.C. early in our marriage, and Kefauver was hard to miss. He'd taken to wearing a coonskin hat after a political opponent's smear campaign claimed he worked in the night for "pinkos and communists," like a stealthy raccoon. The smear campaign failed, and Kefauver's fur hat with the striped tail became his signature.

Now I had raccoons on my mind.

« « The Raccoons » »

AROUND THEN, I WENT WITH my husband to Israel where he was to give a talk. We stayed at the YMCA in Jerusalem, which had a fine library. I began some research on raccoons, learning how they lived, what they ate, and what they looked like. *And* I learned there that wild raccoons were Tennessee's state animal. Perfect!

Back in Massachusetts in my studio, I made a maquette of a raccoon. I felt the size and shape and personality of raccoons would be appealing to children. Then I met with Ledbetter's committee in Belle Meade and spoke about raccoon kits and possibly a raccoon family. The project moved ahead. We walked the boulevard where the sculptures would be sited (which is near the largest municipal park in the state, the beautiful Percy Warner Park, more than two thousand acres). After I left, Ledbetter began raising money by offering a bronze cast of the raccoon maquette as a donor incentive, and I began the anatomical research.

[32]

One of the raccoons in its plaster mold. A sister raccoon in clay waits in the background.

In those days, photos of animals were found in books and magazines. There were thousands of images, but to find a particular pose proved difficult. In my work, a few two-dimensional photos aren't enough; I need the real thing. I got on the phone and called around. The Boston Museum of Science had a stuffed raccoon. A staff member and I brought it up from the dark, Kafkaesque bowels of the museum, so I could study it and photograph it from all sides. There was one pose. A raccoon family would require several poses.

A raccoon skeleton would've been helpful, but finding one seemed much harder, or perhaps I didn't know who to ask. When my husband and I were on a trip to London – later I'll boast about his international standing and the talks he gave – I came across research materials in London's National Gallery Library. The library had an accurate drawing of a raccoon skeleton, *Procyon lotor*, dated 1886. Skeletons don't change much, so this was a great find.

Anecdotes about raccoons say how intelligent they are and describe their mischievous ways, which naturally have to do with finding food. But research confirms that raccoons have highly sensitive paws. Raccoons find their food at night. It's as if they can see with the fingers of their front paws, even under water. This touch sensitivity helps them determine whether something is right for them to eat.

They are lovable to many and a nuisance to others. They're playful, but in life, they're "out of bounds" for petting.

As I was thinking about the design for the work, I wanted the raccoon family to be visible from both sides of the boulevard. I first envisioned raccoons in line on a

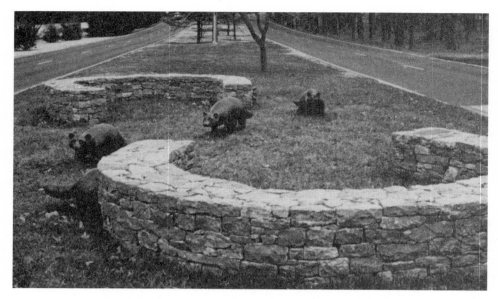

Raccoons playing follow the leader. They're just the right size for kids of all ages to sit on.

fallen tree trunk because trees are abundant in the area. I'd have a raccoon poking its head out of the trunk's hollow center. But, as is my process, I don't settle on a design idea right away, but try to be sensitive to budgets or installation or safety issues. And, in this case, I was working with a team at a distance.

Stone walls, from indigenous limestone and shale, had been suggested by the committee, but stonework might block the animals from view. Still, the walls could help create a welcoming space where a family could sit and watch their children play.

I was swimming one morning when a story came to me, "The Raccoons and the Magic Horseshoes." It was about five raccoons – Rodney, Randy, Ricky, Ruthie, and Rosie – and a giant horse named Rex who'd left his horseshoes behind. An abundance of the raccoons' favorite foods was all around, from crayfish to bumblebees, blueberries to acorns. I wrote, "Legend has it that if you come to the Children's Bridge, you will have good luck. Everyone likes to come to the magic horseshoes, to play with the raccoons, to visit with their neighbor, or just to sit and dream." It worked as an idea.

Stonemasons from Nashville built low, horseshoe-shaped walls to my specifications. I cast and shipped the raccoons, and *The Raccoons and the Magic Horseshoes* sculpture was dedicated October 22, 1995, complete with a marching band of Scottish bagpipers in kilts and full regalia. Afterward, as a few of us stragglers crossed the boulevard, a pickup truck with a large German shepherd in the back

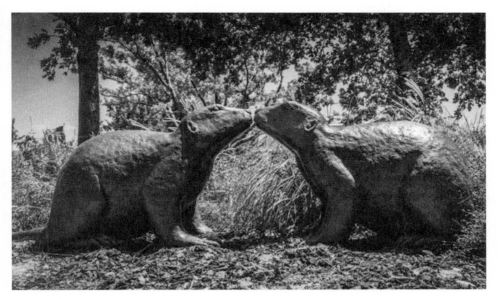

Finished bronze prairie dogs greeting one another. *Friendship* is installed in the Myriad Botanical Gardens, Oklahoma City.

drove slowly by. The dog barked and barked at the raccoons. What a thrill. I knew for certain, then, the raccoons looked real.

<div align="center">« « Prairie Dogs » »</div>

AN OKLAHOMA CITY opportunity came along in 2003. The potential sculpture was to capture the spirit of the Great Plains for a children's garden in the Myriad Botanical Gardens, which is part of a popular and dynamic urban park in downtown Oklahoma City.

Maureen Heffernan was the executive director, and we had worked together when she was at the Coastal Maine Botanical Gardens in Boothbay Harbor, Maine. For the Oklahoma project, she sent me an RFP — an RFP is a Request for Proposal, open to artists, which requests, at the minimum, a concept, budget, images, and credentials. The RFP was the result of a grant Myriad Gardens had received, to purchase a pre-existing sculpture or to commission an artist to create an original one.

An animal sculpture seemed right for a children's garden. As always, the first thing I did was to go to my local public library, where the librarians know me and are so helpful. We collected books on the Great Plains region. I studied the images and discovered prairies dogs are fascinating. I put together a proposal and was chosen as one of six finalists.

I like to study animals in three dimensions and alive if possible. The local Frank-

A preserved prairie dog from the Harvard
Museum of Comparative Zoology.

lin Park Zoo confirmed they had prairie dogs: "If you want to see them in action, you should come on a day when it's cloudy and cool. They don't like the hot sun." I drove out. "Adorable" is the only word. They popped in and out of their ground habitat, barking loudly. After taking many photos, I left.

The prairie dogs at the Boston Science Museum were also in perpetual motion and not easy to photograph, but I managed a few closer shots. The Harvard Museum of Comparative Zoology had found for me a stuffed, slightly shaggy prairie dog from their storage. How incredibly fortunate I was to have institutions close by with these resources.

The pose became clear to me more quickly than usual. Prairie dogs communicate through touch and scent. They greet each other by opening their mouths and touching teeth, which looks like a kiss, but what they are really doing is grooming each other and finding out whether they belong to the same family unit, called a coterie. A coterie has one adult male, two or three adult females, and all of their young under two years old. Coteries can number up to twenty-six, though the average is six. They can occupy an area up to 2.5 acres (1 hectare), but typically it's half that. Amazingly, most coterie burrows have more than 70 entrances.

I knew from experience that if I wanted a child to climb on a sculpture, part or all of it shouldn't be more than about a chair's height, 18 inches or thereabouts. For two prairie dogs on all fours, facing one another, I used that height and calculated a relative length for the animals based on their anatomy.

I got started on the wax maquette. Where the two mouths came together, I made sure there'd be room in the actual size for children to crawl through the archway made by the "kiss." The ears would be something children could hold onto when

they climbed on the sculpture. As I tend to do, I composed a story in my head about the animals. I called these two Patty and Woody (after Patty Page and Woody Guthrie). While I worked, I hummed songs from the musical *Oklahoma!*

I packed up the maquette and flew to Oklahoma City where I met eight or nine unsmiling men and women in a conference room. They were from various arts organizations or were community and civic people.

I took out the maquette, having prepared it as I do for presentations – by applying bronze powder to the wax, mounting it on felt-bottomed marble base, and attaching rotating hardware so the prairie dogs could be viewed from all sides. I explained it was a true-to-scale model, designed for children to interact with, which was my trademark. I gave my design fee and my proposed timeline for the larger sculpture, as well as the casting costs.

Maureen met me later. Though she thought my presentation was outstanding, she said she wasn't so sure the committee wanted me to do the sculpture, as she'd anticipated. The first thing they said was I had no right to ask for an additional design fee. I always charge a design fee as that's where all the real work happens – the research, the creativity, the core of any new creation. Could I withdraw it? In the end I said if Myriad would pay for the shipping of the bronzes, I'd waive the fee. I returned to New England, really wanting to make this sculpture.

After the committee review, Maureen called to say I'd been cut from the list. She disliked the sculpture selected and couldn't understand the committee's choice. I was shattered. I tried to put it behind me. Committees have opinions, of course, and this one had different ideas about what was appropriate for the site. But I had to make an honest assessment of my attitude. I'd gotten my expectations up. I'd assumed I was the best. They should have been happy to have me *even consider* creating a sculpture for them, right? No. This was not a proud moment.

It was the first time I'd had an experience like it, and I hoped never to again.

Then, about a month later, to my astonishment, the family who'd donated the money for the public art grant decided they did not like the committee's choice, nor any of the other entries except mine. Maureen wrote: "We are delighted that Myriad Gardens Foundation is able to commission you to create the Prairie Dog sculpture piece for our children's garden."

I titled the work "Friendship."

« « Research Never Gets Old » »

THE ANIMAL RESEARCH I DO before I make a sculpture not only helps me understand the skeletal and muscular structures, but it's also useful for creating a persona.

Collected images help in understanding an animal's inner world as well as its anatomy.

People have said to me my sculptures make an emotional connection. Though it's a mystery to me how I do this, it's the core of what my work is about. By studying how animals move, their habits, and where and how they live, I can dream up stories about them and create "characters" children will relate to.

It's probably no surprise that some of my favorite animal research had to do with mallards and ducklings. I didn't have mallards in my bathtub, which Robert McCloskey did for a short time when he made sketches for *Make Way for Ducklings*. First, I bought a grocery store duck and put it in cold water to look at how the joints articulate. Maybe I learned something, but it wasn't long before the odor told me to get rid of it.

The Massachusetts Audubon Society had a stuffed mallard, a two-year-old, but it had no feet. The Educational Department of the Museum of Science sent a special messenger to my address with a stuffed mallard, magnificently preserved, along with resource books. I was so grateful. (Remember this was my first public art effort, and I had many committees to please, and most especially McCloskey.)

Several of the ducklings in my proposed sculpture had open mouths as did Mrs. Mallard. I wanted to know what the inside of a duck's mouth looked like. I threw

bread at ducks and rushed forward to get a look inside their beaks. Ha! Even the tamest of ducks at city ponds weren't going to stay around for that.

Someone told me Tufts School of Veterinary Medicine in Grafton, Massachusetts, sometimes had frozen animals to be used for study, animals who'd died from accidents. I called. The woman on the other end of the phone chuckled and told me they just happened to have a mallard. I asked her if it would be possible to defrost the bird so I could examine it.

As one of the vets held the mallard's mouth open, I photographed it. Mallards have bifurcated tongues and many tiny teeth. They dive for food, and these teeth act as a sieve. Water and food are separated. The water flows out from between the teeth and the food stays behind to be swallowed.

My sculpture did not include tiny sharp teeth. Was all that beak research necessary? I think so. Research satisfies the desire to find out more. Curiosity has its rewards despite the old saying about killing the cat. This was proven to me in so many ways in my life – from my husband's world, my childhood, my amazing mother, and from raising my own children.

« « Donald Stories » »

I'M A KID AT HEART, I suppose. My husband Donald Schön – Don – would often ask if I was ever going to grow up. My answer was "I hope not!" In that, I took after my mother. So many happy memories of my childhood were connected to her. She had a great deal of energy and was always on the go. She spoke of herself as a daredevil, telling of times she dove from the highest diving board or flew in an open cockpit plane in 1923. Celia Gross Quint. She had an easy-going way of making everything fun, from cooking for a full house of relatives for a holiday, to helping my father entertain associates in his florist business, such as the men from Holland who sold him bulbs.

She took us swimming – my sister Conny, my brother Earl, and me. We watched her play tennis and learned ourselves. In winter she took us ice skating on nearby Crystal Lake or tobogganing at the local playground. She'd rent just the right size toboggan for all of us – including her. We'd all pile into it and fly downhill.

One of the most important days of my young life was when I got a second-hand bicycle. My beautiful, old, shabby blue bike with half the paint off, gave me freedom, the greatest gift I could possibly have. I have always had an enormous need for freedom. This came from my mother, too, and I believe my husband recognized this in me. I could go on about her, about me, but here I wanted to brag about him.

Don and I married in 1952. I'd graduated from art school, the Boston Museum

School, and he had just graduated from Yale in philosophy. He got a fellowship teaching philosophy at UCLA, and then later while in the army, he lectured as an assistant professor in philosophy at the University of Kansas City. During these times we had four children. I taught sculpture and scrounged for the space to make it. Don got his masters and doctorate from Harvard, also in philosophy. We moved to Washington, D.C., where he worked in the Department of Commerce as director of the Institute for Applied Technology in the National Bureau of Standards. He was an expert in innovation and organization, on ideas about systems and change.

Eventually we moved to Newton, the town just west of Boston where I grew up. In time, Don held the Ford Chair in Urban Studies and Education at Massachusetts Institute of Technology (MIT). He published theories about how we learn and how we do things in practice, in the realities of life. He wrote about improvisation and structure (he played piano and the clarinet – he'd studied music in Paris), and about thinking on one's feet. He was a champion debater – I usually lost when it came to logic, but did pretty well when it came to common sense.

Because of his academic stature, he was invited to give talks internationally. We traveled a lot. One trip, we flew to Madrid and drove to Turin, where the 20th Century Foundation (a research institute) had asked him to give a talk. We were to be the guests of Marella and Gianni Agnelli. I had no idea who they were.

That was pretty typical.

There was no GPS then. Don drove through Spain, southern France, and into northern Italy, relying on his French from years before. We'd stop and ask someone if we were going in the right direction. Much head shaking and dubious hand gestures ensued, but after two days on the road, we made it, arriving exhausted in Turin. At our hotel, the longest-stemmed, most beautiful red roses I'd ever seen in my life awaited us – and my father was a florist. The card, simply engraved card, was from Gianni Agnelli, heir to an automotive and manufacturing fortune.

We were running late. Don was being picked up for a lunch meeting. I was also being picked up to have lunch with Mrs. Agnelli. I was too tired to go anywhere, and I dreaded lunch with a little Italian lady in black who didn't speak English. Don suggested I'd feel better after a shower, that I was expected, and should not disappoint my hosts. He was a good traveler; I was just learning how to get a second wind.

The limousine stopped in front of a stone mansion. My driver escorted me to the door where I was met by a butler. The butler let me to an elevator. Up a level, the door opened to a hall of white marble, spacious enough for a life-size bronze sculpture of a horse and rider by Marino Marini – right in front of me.

I entered a huge room where a stunning woman got up from a couch to greet

me. She had blonde tipped curls, wore a beige sweater and skirt and beige knee socks. I later learned Marella Agnelli had been voted in 1963 one of the best-dressed women in the world – "little Italian lady in black," indeed. Of the Agnelli family, Gianni was said to have made the best marriage of all. Marella Caracciolo di Castagneto was a Neapolitan princess of ancient family heritage, said to have the longest royal neck in Europe. She was a philanthropist and a cofounder of the Pinacoteca Art Museum.

She introduced me to her various friends – from the Olivetti, Rossi, Cinzano families – names I remember. Among these astonishingly beautiful women, all dressed smartly, I felt a bit like the "poor relative."

When it was time for us to go into the dining room I was escorted by my very own *man* dressed in green and gold livery, much like the decor of the room we were entering. The large marble table was supported by elaborately carved gilded wooden legs. The ornate china had what seemed like an endless number of pieces of silverware on either side, plus an assortment of crystal glasses.

With startling white gloves, my man served me the soup course. I had chosen the proper glass for a sip of water as I had watched my hostess. But my confusion over the soup spoon caused a near social catastrophe. Fortunately, my faithful man realized my plight and surreptitiously touched the proper spoon. My face had to be red, but I turned around to the lady on my left and just smiled. Whew. That was close.

« « A Wish Granted » »

In October 1970, Don was asked to give the prestigious Reith Lectures, a series of six annual radio lectures, commissioned by the BBC and broadcast on BBC Radio 4 and the World Service. Former lecturers included Bertrand Russell, Arnold Toynbee, Robert Oppenheimer, and John Kenneth Galbraith. My husband, at 39, was the youngest.

Since Don was so young, the press was eager for interviews. We got phone calls and invitations at our London hotel. The U.S. Embassy people said they'd take care of anything we wanted or needed. They'd provide a car and driver for any trips. I asked if there might be a chance of meeting Henry Moore, as I was a sculptor and revered his work. The positive response came faster than I thought.

Two days later an embassy driver whisked us off to the village of Much Hadham in Hertfordshire, where Irina Radetsky and Henry Moore lived. Mr. Moore gave us a warm hello and welcome. This 70-year-old, well-built man was full of charm and was even sexy. Before we had tea at the house with Irina, Don and I visited

Henry Moore (left), Donald Schön (center), and me in Moore's studio in Hertfordshire, England, which is now part of the Henry Moore Foundation.

Moore's studio, a small building of a single open room. It was simply furnished with a few sculptures and maquettes on various tables. On one wall was a suite of etchings of an elephant skull. Both Don and I were taken with them and desperately wanted one, but Moore tactfully let us know they were out of our price range. Moore picked up a small bronze of a mother and child and slowly turned it over and over. I remember him saying, "We, as artists, and being artists, have limitless freedom to do whatever we want in our art." I had no words to respond to that.

We walked the grounds with him, stopping at his giant sculptures, and as we left each one, Moore gave it a big whack with his hand. The sculpture would "sing" a long, tonal hum. He seemed to love going around like a conductor, bringing the sound out from each work.

At one point, I pulled out the small magnifying glass I always carried. I held it close to one of his sculptures to see its texture. This delighted him, never having done it himself. We looked at surfaces. Afterward I gave him my magnifier and asked him to think of me when he used it.

Henry Moore is quoted as saying, "One never knows what each day is going to bring. The important thing is to be open and ready for it." Thanks to him, I've frequently used the expression, "One never knows." And thanks to my husband's fame (and the embassy's effort), we met Henry Moore, which, like the Agnelli experience, was another chance for me to be open and ready.

NANCY SCHÖN

« « My Giraffe » »

DON WAS HONORED OFTEN over the years, and everything about him enriched my life. He was 6 foot 4, and once told me that he thought of himself as a giraffe. I wasn't surprised. He had many of the animal's lovely characteristics.

He died in 1997. Not too long after, I decided to sculpt a large giraffe. I had sculpted smaller ones, and I loved doing them. To me they were such sweet animals and in making them I felt close to my husband. They took delightful stances, different from any other animal, partly due to their long necks and legs, causing them to be both graceful and to splay their legs when standing still.

There was something healing about making a large giraffe. I designed it so the long neck bent parallel to the floor. Children could swing on it or do chin-ups on it. The head and neck were just at the right height for a child to hug. I named the sculpture *The Reflective Giraffe*. Don had written many articles and books. His most famous and highly influential book was *The Reflective Practitioner*, about how professionals move into the center of their own doubts while taking action, an awareness and reflectivity he called "knowing-in-action." I wanted my giraffe to reflect him.

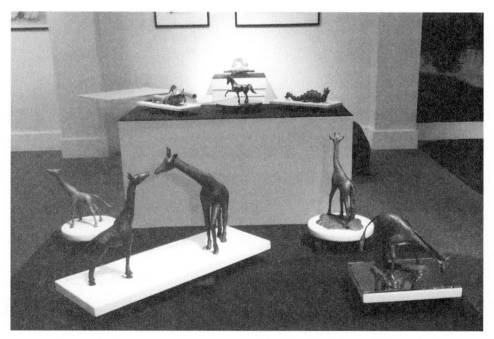

Maquettes of giraffes in "Animal Tales: Sculpture of Nancy Schön" at the Wenham Museum in Massachusetts, 2016.

« 4 »

Magic and Memorials
Children's Literature, Grief, and Hope

ONE DAY, ONE OF MY father's clients, a Chinese restaurant owner who insisted on fresh flower arrangements on his tables, led us – my family – to the cellar of the restaurant kitchen after we had lunch. I was little, and it was as if he were leading us to a secret place. Down the dark stairs and into the light, he presented his set up for growing bean sprouts in water. The trays and white sprouts fascinated me. But at home, when each of the beans he'd put into my hand as a gift sent up a tiny shoot in a dish of water, I was enthralled. This same "magic" was enacted all around me in my father's greenhouses and the gardens. Very young, I was shown how to poke my finger into a pot of soil, drop in a seed, and cover over the hole. Then one had to wait and watch all the pots. *There* – a minute spot of green, a leaf, now a seedling. These were the beginnings of my understanding of change and growth. In my art, the sense of upward movement was for many years an underlying theme.

Children's literature possesses a kind of magic. After the ducklings, children's books were the basis of many (not all) of my public art commissions. I fully embraced this, although I did not plan it. Like the bronze sculpture of Lewis Carroll's *Alice in Wonderland* in Central Park, some of my sculptures came from story characters and were memorials. (*Alice* was commissioned by a New York publisher and art patron as a memorial to his wife.) From A. A. Milne's *Winnie-the-Pooh*, the first of a trio I cast was Eeyore.

« « Eeyore » »

THE NEWTON FREE LIBRARY, established in 1870, was expanded twice as the city grew. The library opened several branches but a new building was needed. Construction began in the 1980s for a 1991 grand opening. The library trustees invited me to be on the art committee for the new space. One of our tasks was to meet with the architects to design an art exhibition gallery.

I volunteered, too, to clean the library's various marble statues. I knew nothing of how to do this but figured I could find out. I called the Marble Institute of America and asked for guidance. The nice man who came on the line said the cleaning process was simple. He told me what to buy and how to accomplish my

Eeyore in clay, ready for casting, 1991 (*left*), and installing Piglet, who's telling Pooh a secret, 2013 (*right*).

task, but warned me it would be grueling. Stubborn me gathered old toothbrushes, toothpicks, and cotton swabs, and climbed up on a ladder for the first statue (thinking it smart to start at the top while I was fresh and less apt to fall over). Well, the nice man was right. Grime removal from marble is messy and arduous. Eeyore was not on my mind then, but I might have sighed like him.

Landscaping for the new building included a children's patio, off the children's department. The head librarian wanted a sculpture there. The committee liked the choice of Eeyore, a lovable character, and they chose me to sculpt him. In Milne's story, Eeyore is supposed to receive a pot of honey and a balloon on a stick for his birthday. Pooh and Piglet, however, arrive with an empty "hunny pot" and a popped balloon. Eeyore, perennially disappointed and gloomy, isn't angry, though. He puts the stick with the broken balloon at its tip, in and out of the pot, making a happy game of it. Balloons don't usually fit inside of pots, but this one does.

E. H. (Ernest Howard) Shepard illustrated Milne's books in the 1920s. I copied as many of his poses of Eeyore as I could find. Then I consulted my own art committee – my grandchildren. Which picture of Eeyore did they like? And I asked myself, which pose could children climb on? I made a maquette of Eeyore, which was approved by the committee.

The Friends of the Library came forward with funds, and I made a contribution. There were other generous donors, particularly a family who had lost their four-year-old son and wanted a memorial to him.

This commission had a firm deadline: the day the new library was to open. I

made the large clay model and got it to the foundry before I left for Moscow to install ducklings there. (More on that in the next chapter.) Sounds easy, but believe me the Moscow tension was thick, and I did not want to let down the library. Thankfully, the foundry work and the installation went smoothly. Eeyore was unveiled and celebrated September 15, 1991.

« « Ten Years Later, Pooh » »

IT'S THE BEGINNING OF APRIL, 2001. My studio's now just behind my house, and I am reading a letter that brings a lump to my throat. Kuzuko and Bill Oliver, two Boston University professors, are telling me about their daughter Sarah, who had died two months before of liver failure and medical complications. She was 20. They ask: Would I create a sculpture of Winnie-the-Pooh?

The way in which the loss expressed in the Olivers' letter connected to my sculpture of Eeyore gave me an extra pang of sadness. From the time she could read, Sarah had loved *Winnie-the-Pooh* and all of A.A Milne's books. Her room was plastered with Pooh drawings and photographs. She loved her Pooh Bear. She was often at the library with her parents and she would visit Eeyore. She worried about him. She would say repeatedly that she thought he was lonely.

She sent a letter to Newton's mayor when she was fourteen to say Eeyore in the snow had no one to talk to or keep him warm. "I am writing to you about a sad little donkey…I believe it is time for that poor old donkey, who waits very patiently by the Newton Public Library for his friend, to be given a late (or early) birthday present: Winnie-the-Pooh."

The mayor's response was encouraging. She had a good idea, he said. Six years passed, however. The board of the library hadn't commissioned Pooh as Sarah had hoped, but after she died, her parents did.

I met with the Olivers. I wanted to know more about Sarah so the sculpture could reflect her in every way possible. I would make a maquette for them, but first we needed city and library approval.

During the ducklings project, I had to get used to not having my own way with schedules and decisions, and I recognized the value of that the more I made public art. Commissions that came my way could take awhile to get started or they overlapped. The length of time for the stages of creation, and the number of meetings involved, could vary, project to project. But funding might possibly have been the hardest. In the case of the Olivers and Pooh, I got the approvals, and with a supporting article in the *Boston Globe* about Sarah and her idea of Pooh joining Eeyore, many friends of the Olivers, Sarah's fellow students, and well-wishers in general sent

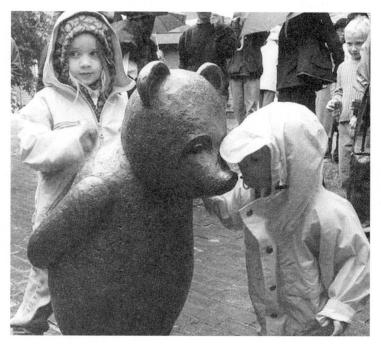

The rain did not dampen the enthusiasm (or affection) of many at Pooh's
dedication, 2002.

money to a memorial account. They worked hard to make Pooh happen.

I had the go-ahead. Once again, I made copies of E. H. Shepard's illustrations. And I congregated my art committee, who had now increased to nine grandchildren. It seemed I always had a grandchild the right size to test out what scale a sculpture might be. I asked what pose they thought *other* children would be attracted to, and a decision was agreed on – after much thought, a few arguments, and much giggling.

I sculpted Pooh in clay and decided to add his hunny pot on its side. The pot would be something little children could sit on, and it provided a focal point between Eeyore and Pooh.

For the dedication, Kazuko and her friends planted flowers and shrubs around the installation (and continued to ensure the gardens are lovely year round). Many came to the library on May 12, 2002, for Pooh's big day. Bill Oliver said, "Sarah can't help but be pleased with her Pooh Bear. I am thrilled to see so many children here. They may never have a thought about Sarah, but I hope someday to see a child sitting on the hunny pot joining Pooh in trying to cheer up Eeyore."

Through such great sorrow, the Olivers maintained impressive dignity. I was honored to help inspire future joy in Sarah's name and to fulfill her dream.

« « Sonja and the Story of Piglet » »

NOW ANOTHER TEN YEARS has passed. It is June 2012. The rain is coming down in torrents. I'm inside the library, having been asked to give a talk to mark the tenth anniversary of Pooh's dedication. On purpose I'm early and sitting alone to go over my notes. An elderly woman, dripping wet, sits right beside me. My first impression isn't good. Her rain hat is askew, her curly grey hair is a mess from the rain, and she wants to interrupt me. I manage to delay her.

During my talk, someone in the group asks wouldn't it be nice to add Tigger to Pooh and Eeyore. People had often suggested this. I nod. Another asks, "How about Piglet?" The woman in the rain hat says, "I want first dibs on Piglet."

Sonja Calabi, in her soft, accented voice came up to me after the talk and introduced herself. She truly wanted to add Piglet to Eeyore and Pooh. I nodded but explained that such a sculpture would be expensive. She asked for my phone number, said she would get in touch, straightened her hat, and stepped out into the rain. I doubted I would hear from her.

But I did. "Could we meet at the library cafe and talk?"

When she entered, Sonja looked like the sophisticated woman she was. As we sat together, she told me about herself and her brother, and this time I was fully absorbed.

Swiss-born, Sonja went to university where she met her husband. When they moved from Switzerland, she left behind a much younger brother and sister, both bright and artistically gifted. Her brother wrote poems and was an accomplished pianist. Her sister was a visual artist. Sonja loved them like her own children. In 1952, she and her husband came to Boston where he taught mathematics.

Eight years later, her brother shot himself. He was 21. The family was devastated. For Sonja's mother, it was unthinkable to bury him "like a dog without the blessings of a priest." It was not easy to find a Catholic priest who would bury someone who had committed suicide. Sonja found a young curate in another city who "took it upon his soul to put our brother's remains into blessed ground while nobody was watching."

Sonja's sister designed a Dominican cross for his grave. The local blacksmith made it in wrought iron. Sonja believed their mother gained comfort from the cross. "It looked so splendid and different."

In 1985, Sonja's sister received an official notice that the part of the cemetery containing their brother's grave was to be razed. (This seems an appalling practice to us, but old burial grounds and cemeteries in Europe are overcrowded.)

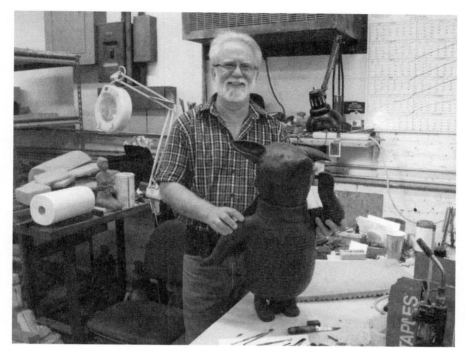

Foundry expert Charlie Hahn preps Piglet for casting.

Sonja sent a message to her nephew: Saw off the cross from its concrete block and hide it. She would retrieve it as soon as she could. She flew to Switzerland. She told me she wept openly as she walked to the train station with that heavy cross to bring it home. "I defied anybody to question me about *sunt lacrimae rerum* (meaning, there are tears in things, or tears at the heart of life itself)."

As we continued our conversation, she told me her brother had characteristics like Piglet. He was timid but brave, and he was able to conquer his fears. Besides, Piglet and Pooh loved each other, and they were best friends.

She wanted the sculpture to commemorate her brother.

« « Piglet's Pose » »

As we spent time together, I learned that Sonja was well-versed in art history, fluent in several languages, and had lived in France and Italy. She worked with a Boston art gallery, curated a private collection, volunteered at the McMullen Museum of Art at Boston College, and sponsored art scholarships.

For this sculpture, I did not call on my grandchildren to get their reactions to different poses. Sonja had definite ideas. She wanted Piglet to possess characteristics

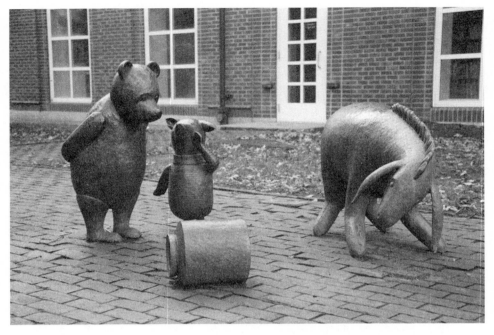

A. A. Milne's beloved characters hope, as do others, that Tigger will join them one day.

that reminded her of her beloved brother.

We met again in June. She followed up by writing to me, "Let's congratulate each other on the swift, decisive, and neat decision on the figure of our Piglet, and its orientation towards Pooh, and its placement in the group outside the library. You brought various copied images of Piglet and a maquette, just what I needed for my easy choice. And then you came to meet my fancy with your willingness to overcome the obstacle of only one foot of the Piglet image on the ground by pulling the other foot down too, to give it a more secure position. Thank you! Excellent cooperation."

As I built the model, Sonja came by my studio several times to see how things were going. She sent her own drawing to show how she saw the sculpture, how she wanted Piglet to be telling Pooh a secret. "What the secret is, let the kids surmise and make up stories about it...Piglet stops for just an instant while Pooh walks along considering the problem. This image gives you the scarf you like, and also his knock-kneed legs, like my little brother's, whom we called Piglet."

I called her when I'd nearly finished so we could do some last minute tweaking to the clay. She suggested bending one ear forward more, and the other ear backward a little. I took the final clay figure of Piglet to the foundry and several weeks

later I worked on the wax casts of him, to make sure they were as perfect as I could make them, with every meticulous detail in place.

Sonja covered all the casting costs. The library had funds for the installation. And on May 11, 2013, Piglet was dedicated. Unfortunately, Sonja had to be in Europe and missed the flurry of activities around Piglet, Pooh, and Eeyore. When she returned, she wrote a note to thank me for her Piglet. With Piglet in place, she said, "I think the characters have suddenly started to talk to each other…"

« « McCloskey's Children's Books » »

THE HAMILTON COMMUNITY FOUNDATION in Hamilton, Ohio was approaching its 50th anniversary. The director got in touch with me in November 1999, eager to honor McCloskey with a sculpture. McCloskey was born in Hamilton in 1914. The first book he wrote and illustrated, *Lentil*, was set in Hamilton. It's about a boy, his harmonica, and his dog, and the drawings are based on his memories of growing up there.

McCloskey was a dear man of high principles who had a delightful sense of humor, much reflected in his books. I feel as if I praise him each time I mention his name. Here's an example of his humility and humor, excerpted from his acceptance speech when he was awarded the 1942 Caldecott medal for *Make Way for Ducklings*.

"…Yes, I'm working on children's illustration. I'm proud of that. But I'm still for hire – to paint, sculpt, whittle, or blast if it's on some job that will bring pleasure and be used, whether it be in a bank, post office, or chicken coop."

To receive a Caldecott (for the previous year's best U.S. children's book) was a high honor then, as it is now.

I called to tell him about the foundation's idea. I was eager, in turn, to honor him with a sculpture. Lentil seemed the obvious choice. McCloskey was reluctant. "Okay," I said, "I'll make a maquette, and if you don't like it, we'll forget all about it." He said I shouldn't expect him to accept my design, and I agreed it was a risk.

I created a maquette based on one of the book's illustrations – a boy struts forward, playing his harmonica, and his dog trots behind. McCloskey's mastery of lines, showing form, guided me in making the model.

When the maquette was ready, I flew to Bangor, Maine on a beastly cold day. The heater in the car I'd rented stopped working. But I drove to the coast and was treated to hot soup when I arrived. During that first hour Bob said more than once he didn't think the sculpture was a good idea. My heart sank. We left the table and

Robert McCloskey visiting the studio to see how the full-size Lentil is coming along.

moved to his study. I unwrapped the maquette and set it in front of him. His face was expressionless. I had come a long way to be rejected, but I kept telling myself that *Lentil* was his book, they were his drawings, his creation. I understood.

He looked it over, rotating it on its base, taking his time. Eventually that poker face broke into a grin. He said he loved it. He told me that the dog, named Finnegan, had been mostly Irish setter, which meant I should add fringes of fur, or feathering as the breeders call it, to the dog's legs. By feathering the tail, it would be strong enough to hold children who sat on it.

I asked how Lentil got his name. One summer after Bob had moved east for art school and to paint, he met a flaky man in Provincetown on Cape Cod. The guy talked about the pyramids being built on lentils.

Bob smiled. I didn't ask for more.

I flew to Ohio not long afterward to meet the foundation members in Hamilton. They wanted to name the small garden where the sculpture would be placed after McCloskey. Bob, ever modest and not interested in celebrity, was against this.

At the meeting, we set the date for the dedication, September 21, 2001. I flew home to work on the casting and shipping. The name of the park would come later.

In the book, Lentil is young, but because it is an outdoor sculpture, I made him six feet tall. This height and his walking pose meant I needed to be sure he was

mounted safely and could not fall in any direction. (Despite an underground plate welded to Lentil's standing foot, he wasn't as stable as he should be. After the dedication ceremony, the men who reinstalled him attached him to a large half globe buried underground, an ingenious solution. But that's jumping ahead.)

The financials and the copyright release were taken care of. The foundation was in close contact – and even visited my studio – over the months as I made the armature and the clay models. Susie, my youngest daughter, noticed I'd made one of Lentil's arms longer than the other. I never resented how she could spot what I couldn't see. She was right about the arm, and I fixed it. I also put a lizard poking out of Lentil's pocket. This was not in McCloskey's drawings, but I felt it was in the right spirit (thinking of the pyramid man on Cape Cod) and also a way of making the work my own.

At the foundry I patted every inch of the new casting, especially Lentil's spiky hair, to make sure there were no sharp points anywhere that could cause harm. I couldn't wait for Bob to see it.

Hamilton held a contest for children to name the dog, and the children voted for the name Harmony. The sculpture was shipped and installed in a striking garden designed by a landscape architect. Everything was on time. Invitations went out for the foundation's anniversary celebration and the sculpture's dedication.

Then without warning, September 11th happened. The country was in chaos. The foundation wasn't sure whether they should hold the event. So many were sad, frightened, and angry. Nothing like this had ever happened in the United States. Over several days before my flight on the 20th, many discussions took place by phone with the foundation. I felt strongly we should go ahead and not cancel. Life must go on. In the end, they agreed to go ahead. I flew, as planned, on a plane with only three other passengers. Hamilton's celebration proved a warm and much-needed expression of humanity – and harmony.

McCloskey's book, *Blueberries for Sal* became the inspiration for another work of public art. I created Sal's Bear for Coastal Maine Botanical Gardens, with its 270 acres of tidal land in Boothbay Harbor.

Bob lived with his family on an island off Maine's coast. Life on the island with his daughters, Sally and Jane, and some of their neighbors, are featured in four of his books. In *Blueberries for Sal* (1948), Sal (short for Sally) gathers berries on a hill in Maine. She and a bear cub follow one another's mother by mistake. I sculpted a bear – not scary and at a scale for kids' play. A tipped over pail of blueberries is nearby. *Sal's Bear* was to be the signature sculpture for the children's garden. The Botanical Garden planted blueberries close to the sculpture for children to pick

The chickadee, by the bucket of blueberries, looks ready to greet Sal's bear.

when they visit. I also sculpted the state bird of Maine, the black-capped chicka-
dee, as well as a spray of pine cones. The pine cone is the state flower. These I
included to be a learning component for children, which I like to add, when it's
appropriate.

At the garden, I worked with the executive director, Maureen Heffernan. (She
later took the job at Oklahoma City's Myriad Botanical Gardens where my prairie
dogs "kiss.") I dedicated *Sal's Bear* to Bob, in memoriam, on June 24, 2010.

« « Owl and Pussycat » »

A SCULPTURE RELATED TO "The Owl and the Pussy Cat," Edward Lear's famous
poem for children, was proposed for a local park in Boston in 2003. I looked at a
number of artist interpretations of the nursery rhyme and came up with my own
idea. I began with Piggy-wig. In the poem, the cat and the owl sail for a year and
a day in search of a ring so they can marry. They choose the ring in a pig's (Piggy-
wig) nose. They get married and dance by the light of the moon.

I thought a pig would be lots of fun for kids. I built him, sculpted him, and
although funds for the project didn't materialize, I decided to take him to the

foundry to be cast. Always the optimist, I also made an armature for the cat. When it became clear the project was going nowhere, I stopped making the cat.

I have a wonderful pig! I considered turning him into a piggy bank to raise money for a nonprofit. (Large sculptures are hollow.) He's called Bacon now, as people seemed to find the name amusing. He is intact, with no piggy bank holes. He's been in several art exhibitions, and has been much enjoyed by children. And the cat has been useful as an example to show how a large sculpture is made. Much of the armature is revealed under clay, Styrofoam, wires, and wooden shish-kebob sticks. I love having it.

As I write, the possibility of the *Owl and the Pussy Cat* sculpture has come alive again as a possible project. Time will tell.

« « Memorials » »

I'VE WRITTEN ABOUT A NUMBER of my public art projects, which were commissioned to honor others. What's behind these projects matters to me. Sometimes, even the most atrocious, heinous event can be turned into a peaceful, loving, contemplative environment, one that can bring comfort.

Public art has many purposes and touches many people in different ways. Perhaps because I've used animals as metaphors, my sculptures have tended to be positive. But whenever a work honors the memory of a loss – whether of a child or an adult, whether from a horrific event or a drawn-out illness – the making of the work and the story behind it are deeply affecting. I can't bring back the one lost, through bronze, but I can, or can try to, create a sculpture that echoes the child's spirit and bring positive thoughts to others, to generations who never knew the departed person.

« « The Joy of Children » »

SO MANY OF THE STORIES behind my sculptures begin with a phone call. This one, in 1995, shook me. When I realized who was calling, I felt a current of deep sympathy rush through me. It was Barbara Pryor, mother of Sarah Pryor, nine years old, who had disappeared ten years previously. She wanted to know what it would take for me to do a sculpture in remembrance of Sarah.

I invited Barbara to my studio, which at that time was in Wayland, in the same small town in Massachusetts, 40 miles west of Boston, where Sarah died.

Barbara and I both were in tears as she told me about the family's move from Pittsburgh, how they were settling in, and about the horrible day, never to be

forgotten. Law enforcement agencies and hundreds of volunteers searched the area for weeks, and then months, but found no trace of her.

She told me how Sarah loved to go sledding before breakfast with her dog Katie, a border collie. Once Barbara suggested that Sarah wait until after school to sled. Sarah smiled, put her hands on her hips, and said, "Mom, what if the sun comes out and melts all the snow?"

The sculpture Barbara wanted was one of a young girl. As we talked, I said gently that experience had shown me that children tend to glance at sculptures of people and move on. But a child will make a parent stop at a sculpture of an animal, to pet or hug or talk to the sculpture. Barbara left with the thought that we might make something joyful that children could have fun with.

How might I make a "living memorial" children could interact with? For some reason, I remembered the John F. Kennedy funeral procession with the riderless horse, a metaphor for Kennedy's absence and death. And I put that together with Sarah's dog Katie.

This sad mother was willing to try an experiment. She brought a sled from her garage to Hannah Williams Park, a local park, where we hoped the sculpture could go. I brought a friend's dog. At the park, I asked kids to come over to the sled and dog. Barbara, her husband Andrew, and I watched. The kids sat on the sled and played with the dog, which is what I'd hoped. Barbara and Andrew accepted the idea: an empty sled and dog.

My veterinarian knew of a woman in the area who raised border collies, and I met her and took photos. I made a maquette for the Pryors. Barbara became the moving force for raising money from the cultural council and selectmen. For donors, I made a tiny sled to be worn as a pendant or pin, which I cast and finished in gold, with a garnet added, which was Sarah's birthstone.

With tireless energy and enthusiasm for the sculpture, Barbara, Andrew, their other children, her mother, her work colleagues, her friends, all got out and helped. It was a magnificent show of love and caring. The police and several district attorneys were involved, along with neighbors and businesses who volunteered and contributed.

Eleven years after Sarah's disappearance, *The Joy of Children* was installed in the Hannah Williams Park, a lovely park with a huge jungle-gym yards away, a nice place for children to meet other children, for mothers to meet, and all to watch after one another.

NANCY SCHÖN

« « Butterfly Birdbath Sculpture » »

I WAS CALLED TO MEET WITH a group of friends, neighbors, staff, and family with the Roxbury Tenants of Harvard, a nonprofit affordable housing organization in Boston. A young woman, 24 years old, had grown up in Mission Hill, an area this organization supports in its work. She was in New York in graduate school at John Jay College. On February 25, 2006, a 911 caller reported her body along a roadside in Brooklyn.

This inconsolable group had gathered to find some way to remember her. The neighborhood was distraught with anger and heartache. Her mother and older sister suggested a garden. There was an empty lot a few houses away from their house. Her sister said later in an interview, she wanted the garden, "…to be a place for people to find a sense of tranquility and peace and hope." She believed her sister was that way, giving others a sense of calm.

The group agreed on the theme "The River of Life." Two designers offered to create the garden – Andrea Taff and Jennie Smith, an English landscaper-artist. I was asked to join them.

At a July 2007 meeting, I presented my proposed composition for a sculpture to a public art funder (the Browne Fund for the improvement of public spaces in Boston), the family, and other supporters of the project. Instead of praise, I was met with silent rejection. Had the composition I put together been my best effort? Had I made an assumption that the group would just accept the idea because it was mine? I hadn't listened to the voice inside that quietly told me the truth. I usually know when something works or not. I was embarrassed, furious at myself, ashamed. Why hadn't I tossed that little model back into the wax bucket to melt it? Why didn't I keep trying for something better?

My next move was to go to the Newton Free Library where I was greeted with big smiles and hellos. Thank heavens they didn't know about my recent rejection. I researched monarch butterflies, the most recognizable butterfly species. The butterfly was an appropriate metaphor I believed, a way to turn a horror into something positive – to the extent that is possible. Monarchs have symbolic meanings in many cultures. Words such as *transformation, spiritual growth*, and *endurance* are associations.

I met with Jennie, and after we discussed other designs, I came up with one that was more elegant and sensitive. The committee and the Browne Fund unanimously approved my new design: a pair of large bronze monarchs that seem to have landed across from one another on large stones.

Now I needed to look for the right stones. Charlie Precourt at Precourt Ar-

chitectural Stonework in Sudbury, Massachusetts greeted me with a warm hand, covered with calluses, and a boisterous shout of "Hiya, Nancy girl!" (This kind of thing amuses me, as I am decades from "girl.")

In his roaring Bobcat, we toured his acreage, which had every conceivable type of stone, used for paving-stone designs or huge architectural stone walls. With the fork lift, Charlie scooped up boulders we liked and set them on a level spot. He moved them around like clumsy marbles. Our choices had to fit next to one another, with the one on top being secure. They would eventually be fastened with unseen rods, but the less work the rods had to do, the better.

The top stone would also be carved to catch water for a birdbath. We chose three and discussed delivery costs to the site.

Meanwhile Jennie and Andrea were preparing the garden in a way to draw people in, to rest and meditate. They planted fragrant shrubs to attract butterflies and birds. Jennie laid beautiful blueish-green pebbled glass, forming a mosaic walkway for the River of Life theme. Both Andrea and Jennie were part of Community Outreach Group for Landscape Design, a nonprofit. This was their gift to the community.

We thought things were going along smoothly. Newspapers gave the project excellent coverage, and the Browne Fund had come through with a grant. But then — a major balk. The family pulled out. This too felt like a failure. We were shocked. With many meetings and phone calls, we attempted to uncover the misunderstandings.

Communication is difficult in such cases. Perhaps that's the lesson in public art memorial works. Grief presents obstacles, not intended to be obstructive. The sculpture was completed and installed. The finished garden was a masterful work of beauty. Unfortunately, only neighbors and members of the Roxbury Tenants of Harvard had keys to the arched wrought-iron gate. The garden was not open to the public. At the dedication on May 22, 2010, I said,

> *The two butterflies facing each other symbolize the community coming together. I have chosen the butterfly as a symbol of spiritual transformation, human frailty, the ephemeral nature of physical existence, and the positive beauty of nature.*

These words and ideas cannot replace a loss. A parent losing a child, a sibling losing a brother or sister — these experiences are unimaginably sad, full of inconceivable pain.

But whether reflecting stories of literature, whether works of dedication or the commemorative works to remember others, I've wanted my work to bring a smile or solace. And there's yet another kind of experience — the consolation and joy of something magical.

Lore for dragons includes different stories about the sources of a dragon's magic.
The protuberance on the top of its head allows it to fly.

« « Dragon Magic » »

BEFORE THE GARDEN PROJECT, I was creating dragons. The first was for the dean
of Harvard's Business School, John McArthur, who in 1992 wanted to create a play
space for children of the faculty. You won't be surprised that he wanted a replica of
the ducklings. After thinking about how he and his staff envisioned a work several
feet long (like the duckling sculpture), and after great fun researching dragons and
dragon lore, I proposed a thirty-two foot, friendly-faced dragon with a long tail,
on which children could sit or play along his back. The tail had a heart on its tip.
This idea and the maquette I made were approved enthusiastically.

Months passed. I was asked to be patient, and I moved to other projects. Then
a letter from McArthur arrived to say he regretted the project was not going for-
ward. It would have been a spectacular landmark for the school.

So, the commission was canceled. By this time, I was finally charging design fees
up front. The major work of a commission takes place during concept develop-
ment, including research. It was also true that after all that work was done, some-
one could cancel and leave me unpaid after I'd spent a great deal of time and effort.
I had learned this lesson when a large hospital commission had been accepted, but
then canceled due to lack of funding. Fortunately, in the case of my first dragon,
the design fee was paid, and I retained all rights to my design.

A year or so later, I decided to shrink the length of the dragon and start building
him. My husband had died about this time, and it was important to keep busy.

Even if I didn't feel like working, I knew I would feel better. Before I'd finished the model, I heard from a woman in Dorchester, Massachusetts, who was raising money for a new park in a neighborhood she described as impoverished. She would make this the most beautiful park in Boston, and just by chance, she was looking for a sculpture of a dragon. I was flabbergasted. Was this for real? She told me she was in the process of raising the money and would get back to me sometime. When I heard the word "sometime," I figured this was a lovely idea that would never happen.

Some weeks later, I received a phone call from David Sexton who was visiting Boston. He wanted to know if I could create a replica of Mrs. Mallard and her ducklings for a park in Naples, Florida. He was the executor of an estate, and the deceased had left money for a sculpture that children could play on. As always, I explained my promise to Robert McCloskey. However, I invited David and his wife to take a look at my clay dragon in process and talk about other possibilities. His wife loved the dragon immediately. Yay for wives! She thought he was perfect.

The dragon, donated to the children of Naples by Charles and Virginia Jacobsen was installed on October 25, 2001. I was grateful, as I was very fond of this creature.

Time had passed since the earlier call about the park in Dorchester. The woman called again. Her name is Ruth Clarke. I explained, now, that the dragon I could make would not be totally unique, but could be recast easily and save money. The two sculptures would be 1500 miles apart. I added to the Dorchester design a stack of books – this dragon had magic and smarts, and might encourage an interest in learning.

Clarke's amazing efforts had raised money from a community that at the time was crime ridden and plagued by drug problems. She worked tirelessly, not only for the park but for my dragon. She believed that if she built a beautiful park, people would respect it and care for it. Her park is called the Nonquit Street Green.

This dragon was mounted on Bomanite, a cement formed by pressing a 4 foot by 4 foot rubber mold on top of wet cement to mimic stone or paver configurations. The Capizzi crew installed the sculpture, and it was dedicated in 2003. For the dedication, neighborhood families decorated dragon cookies and made dragon punch. They planted beds of snapdragons all around. Ted Kennedy read Ogden Nash's "The Tale of Custard the Dragon." Teresa Heinz Kerry, Bernard Margolis, Hubert Jones (also known as Hubie, who has supported nonprofits, led Boston University's School of Social Work, started a children's choir, and been a powerful African American activist for diversity and social change), and Thomas Menino and his wife Angela – this group read other dragon stories. To me, the day and

community spirit was magical.

This is what the Boston Art Commission has posted on their website about the dragon: "He is the invention of Nancy Schön, whose interest in creating interactive sculptures that people – especially children – can touch has made her a leader in the new genre of play sculpture." I probably don't need to add how proud I am of that.

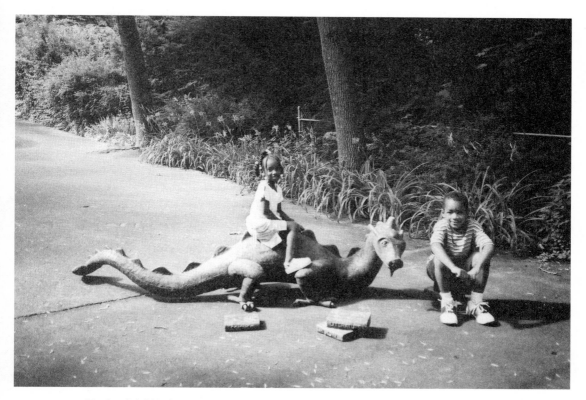

Neighborhood children hang out with *A Dragon for Dorchester*. Kids are encouraged to touch the magic "gem" on its forehead for good fortune and to improve their grades.

« 5 »

How the Ducklings Got to Moscow
Make Way for Dignitaries

THOSE DUCKLINGS. They are loved. They've been bootied in winter, bonnet-topped in spring, and dressed as "soxlings" in Red Sox uniforms. They've been serenaded to, paraded to, selfied, and "ducknapped."

They've even been visited by the Secret Service.

That was on the first of June 1990, when First Lady Barbara Bush and First Lady Raisa Gorbachev from the Soviet Union, joined young Boston students in the Public Garden to see Mrs. Mallard and her ducklings. The students were from the Mather School, the oldest public elementary school in North America (est. 1639). The photo op went well. Who knows what the Secret Service thought, but the two first ladies enjoyed the "dear ducks."

Soon after, Suzanne de Monchaux (my partner for getting the ducklings project through all those public art committee meetings in Boston) said she thought Mrs. Bush should give Mrs. Gorbachev a replica of the sculpture as a gift from the children of the United States to the children of the Soviet Union.

A big idea in simple terms. That was like Suzanne. I was doubtful, and that was like me. I called Robert McCloskey to see what he thought. He surprised me by saying that as long as it was for children, he was on board.

With the help of a public relations professional, Suzanne and I wrote a letter to Mrs. Bush. I sent it off on June 22 and returned to ongoing studio projects. After two weeks or so, Susan Porter Rose, Mrs. Bush's Chief of Staff at the White House, left an upbeat message on my answering machine. Our idea was "under consideration." Mrs. Bush and Mrs. Gorbachev were enthusiastic.

« « More than Just a Good Idea » »

IN THE BEGINNING, I got a kick out of the calls back and forth with Mrs. Bush's staff at the White House. Then the idea took a turn. The stakes rose in a way I could never have imagined. Susan Porter Rose told me the ducklings would go to Moscow as part of the first ladies' participation in "the Summit ceremonies." The START Treaty, between the U.S. and the U.S.S.R. for the reduction and limitation of strategic offensive arms, was coming up. The sculpture would be part

First Ladies Raisa Gorbachev and Barbara Bush in a photo-op at the ducks in the
Public Garden, 1990.

of the celebration.

Oh my God! This was big. You know that lighter-than-air, feet-off-the-ground, grinning, jumping-up-and-down, yippee feeling? I had it.

In September, the project became official but not public. The initial schedule had me, the ducklings, and an installation team arriving in Moscow after Christmas. The treaty signing was planned for January, but there was no firm date.

Hundreds of details and questions surfaced.

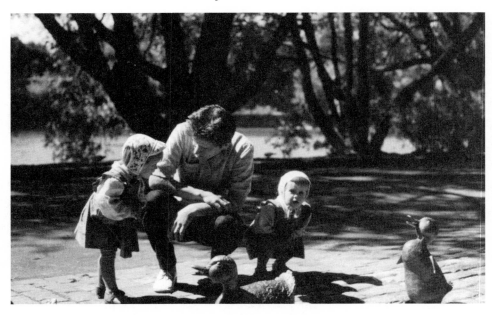

An informal greeting of the ducklings in Novodevichy Park in Moscow.

I could not go forward with recasting the ducks without funding. Private citizens, before donating, needed confirmation of this project. The White House sent confirmation in October yet restricted our sharing information about many details of the project. Thankfully a corporate sponsor came forward and agreed to underwrite the casting. I could get started.

I brought out from storage nine very heavy molds, which I'd used for casting the Boston ducklings. I delivered them to the Renaissance Foundry in Connecticut. Ron Cavalier, owner of the foundry, understood we needed to get the ducks for Moscow ready as soon as possible. He and his assistants would start pouring the waxes.

In November, according to the White House, our project needed a financial agent. The government could not manage the funds raised, because some donations might come from companies doing business with the U.S.S.R.. That would be a conflict of interest.

Nancy Coolidge, Executive Director of the Society for the Preservation of New England Antiquities (SPNEA), had organized the Adopt-a-Duck campaign for the Boston ducklings. She and SPNEA were an excellent choice to handle the funds, and Nancy was someone the White House could work with. She also understood how tough fund-raising could be.

I called Ollie Capizzi, whose company had installed the Public Garden duck-

lings. Would he like to put together costs for doing the same job in Moscow? His answer was a roaring yes.

When Nancy and I got his budget, everything from ten-ton trucks to pantyhose were on his list. We deleted the pantyhose along with other gifts he planned to give the Soviets. We weren't fund-raising for *that*. But there was a reason for the trucks. The White House was working on getting a cargo plane able to carry the tons of materials for the installation. Our cargo list at that point included the crated sculptures when ready, hundreds of cobblestones, two trucks, a backhoe, a compressor, a generator, saws, torches, sand, cement, gravel, compacted stone, a shed and heater, and two-pages of other tools, equipment, and supplies. We had to take with us every grain of sand, water, fuels, and heavy equipment needed. This was at the direction of the White House and State Department. We could assume nothing would be on hand in Moscow.

Did we know, too, that we might need to take our own food with us? The city had food shortages, food lines, and empty cases in the markets. We couldn't be perceived as taking food away from anyone. Besides food might not be available for us anyway.

« « Squeezed for Time » »

WOULD WE HAVE AN INTERPRETER? Where would we stay? What about visas? What about the return home for Ollie's team and the equipment? Security for the work site?

Before Thanksgiving the project picked up. The treaty signing was tentatively scheduled for January 6th, 1991, and the sculpture needed to be installed and ready before then. The date for our trip moved up to mid-December, possibly earlier – no way! I got in touch with the foundry about the new finish date, and my worrying rose a notch.

Away from stressful meetings, I visited the Public Garden, counted the cobblestones under the ducklings and made a diagram. I wanted the same type of cobblestones for Moscow, to make the gift more closely aligned with the Boston ducklings. I met with the architect who did the Boston site planning. He used my diagram and supplied additional information and suggestions to the U.S. Embassy, specifically to Rebecca Matlock, wife of Jack Matlock, the U.S. Ambassador. Rebecca had been working with Raisa Gorbachev and her staff to select a site in Moscow.

When Rebecca Matlock told Susan Porter Rose that Mrs. Gorbachev, who wanted "to find the most beautiful place in all of Moscow," had indeed found it,

I was relieved. The location was fifteen minutes from Red Square, near a pond that had ducks in it, and near a sixteenth-century convent, well-known because of those buried in the cemetery next to it: Khrushchev, Chekhov, Prokofiev, Shostakovich, and Stanislavsky. That was impressive.

« « The Statecraft of Wording » »

JULIA TRUBIKHINA, WHO HAD TRANSLATED *Make Way for Ducklings* into Russian, was coming to Boston. This was fortunate because, through Susan and the State Department, I'd been receiving faxes about the dedication plaque, to be in Russian and English. The plaque needed to be cast in bronze, but everyone seemed to have ideas for how it should be worded, and it kept changing. When I met with Julia, I showed her the Russian translation for this:

> *This sculpture was a gift from the children of the United States of America to the children of the Soviet Union – based on the beloved story Make Way for Ducklings – by Robert McCloskey – sculpture by Nancy Schön*

Julia had an excellent command of English. She said "Make Way for Ducklings" was translated as "Forgive the Ducks." Her face told me other things were also "off." She provided Russian wording to fix the problems.

Suzanne de Monchaux wanted this change:

> *This sculpture is a gift to the children of the Soviet Union on behalf of the children of the United States of America…*

The sculpture was not directly from the children, she said. The fact was, those paying for the project were paying for it on behalf of the children.

I wanted to add "in love and friendship." Susan wasn't sure the Bushes would have said that. I maintained it was my sculpture, my gift, and those words expressed something important to me.

Now this wording:

> *This sculpture is a gift to the children of the Soviet Union on behalf of the children of the United States as an expression of love and friendship. It is based on the beloved American story Make Way for Ducklings by Robert McCloskey. Sculpture by Nancy Schön.*

Washington sent its translation. "Forgive the Ducks" was now "Let the Ducks

Make Way for Ducklings translated into Russian.

Pass." In retrospect, I can laugh, but it annoyed me then. Every time the State Department sent a translation, it was different, and it didn't follow the translation suggestions given by Julia.

At last, the White House faxed a final version. (So thought I!) I sped off to the typesetter. How should the lines for each language break? What about the punctuation? Of course there wasn't a reasonable amount of time for the plaque's casting, so it had to be rushed. Practically every day, our departure date changed. From the White House: Ready by December 7th?

« « Problem 1, Problem 2, Problem 3 . . . » »

IN THE FRENZY OF THOSE DAYS, Susan and I called one another at all hours. She never faltered as we ran into one difficulty after another. She'd say, "Don't worry. We'll work it out."

Nancy at SPNEA and I were both feeling disheartened nevertheless. Sponsoring

ducklings in the United States for a historic park was different from doing the same for a country considered a long-time enemy, despite the planned treaty and despite the ducklings being for children. (Eventually the bulk of the money for the project was raised through foundations, corporations, private donors, and by friends of Barbara Bush. Susan made much of this happen.)

On November 30th another faxed memorandum arrived – this one about visas, immunizations, clothing, and personal supplies, including peanut butter and crackers. Be prepared for another date change. Be prepared to fly out with only 24-hours' notice.

On December 3rd the chief engineer of the U.S.S.R., Yury A. Shilobreyev, was in Boston about another project. Also in town was a representative of Perestroika Joint Venture, the Soviet construction company that would be working with Ollie Capizzi's men to install the ducks. Ollie and I (among others) met with the Soviets, who were efficient and professional. The goal was to reduce the tonnage being shipped, particularly the need for trucks. They told Ollie they could dig out the small trench for the sculpture's concrete footings for $65,000, with an additional $5,000 for labor. In 1991, those fees were shocking.

By now in this book, it's probably obvious that I'm excitable, energetic, and grateful, as well as impatient, headstrong, and possessing my fair share of character flaws. Imagine what it was like working with personalities even more excitable, involved in a logistically complicated international project with funding pressures and uncertain schedules. I am thinking of Ollie. He did not "lose it" at this meeting, but at other times before the ducklings got to Moscow, I was convinced his complaining about "the Russians" and Susan and whatever else crossed his mind, would jeopardize the project.

As the meeting with the Soviets went on, a financial compromise was reached, and I was glad to hear the visitors from Moscow say they thought the chosen site was perfect.

I went to the foundry. Not good news. To my utter horror, the ducks were in pieces on everybody's work benches. They had not been welded together nor had the rods (which connect to steel plates for stability) been welded onto the feet. Just as well – the rods had been cut too short. This would have been a nightmare for the installation in Moscow.

No matter what I did or said, if I stood on my head, if I wrote it down, if I drew it, if I told every single person in the foundry all the same thing, it was as though they couldn't read or add two and two. I threw up my hands. Not one duck was ready. They were not numbered properly. And it was only five days to departure. They had to be welded, chased (which was why I was there), labeled, and prepared

for crating as per Ollie's instructions.

I really liked Ron Cavalier personally and all of his staff. Similar to the life of artists, foundries struggle financially. But that day I was beside myself. Ron was angry in return. How could the ducks possibly be ready? "You moved us up another week. We never told you they would be ready."

I went home defeated. I knew the schedule was at fault but I couldn't change it. Ron and I sorted it out, and we got the ducks ready. Next trip to the foundry, I was up and leaving at 6 a.m. because there was a stop off first at Ollie's company. He and some of his group were also heading to the foundry, to crate the ducks and drive them back to Massachusetts. I kissed Don good-bye between patches of shaving cream – we hardly saw one another during this craziness – and drove to Capizzi Company. Ollie's entire staff was there and giddy. Ollie announced he'd been up all night and "had written something." He put on a performance that was absolutely marvelous. His song and dance had "Capizzi International" flying into space with the ducklings trailing behind, off into eternity. This was a happy moment amid the stress.

Bob McCloskey met us at the foundry. He had lost his wife Peg in October and was grieving. Her illness had been exhausting. That day, we all hoped, would lift Bob's spirits. He and I watched as the patina was finished on the last duck. The ducks went into their crates, photos were taken, and then we raised glasses to toast everyone.

Those of us going – five of Ollie's most skilled – Gordon Goodband, foreman; Ollie's son, Anthony Capizzi (Tony C.); Manuel Rocha (Manny); Anthony Antonio (Tony A.); and Rui Vincente – and me – continued to be on 24-hour alert. Ollie said the men would not go if they couldn't be back for Christmas. Packed bags with warm clothes for the installation's dirty work sat by the door. Tools and cobblestones had been palletized; and the cast plaque, wrapped and ready. Did we have a plane? No.

Now Susan sounded deflated. By December 12th, General Trefry said there weren't any planes available. Airlifting food to the Soviet Union had priority, as well as the situation in the Persian Gulf. Not long after, she let us know our departure date might be the 6th of January. She could do nothing about it, nor could anyone know if and when we'd get to Moscow.

Ollie didn't seem to understand there was a war starting. The international situation was not going to accommodate his schedule. Talking with him on the phone, trying to reason with him, exhausted me. His complaints were worse than ever. He was brilliant in his field, though hot-headed; he was lovable, though impossible.

Photocopies of architectural drawings from the architects in Moscow arrived

from the White House on December 17th. The drawings depicted the ducks on a platform raised about six inches or so. A platform did not make the ducks available to children. It was dangerous for them. After I spoke with Susan about it, she sent Polaroids of the park's wide walkway. Several raised platforms existed already along the way. The decision made sense, but it was wrong for the ducklings.

« « War » »

THE YEAR TURNED. It felt as if the world was falling apart – starving Soviets, famine and civil war in the Sudan, Lithuania and Baltic states sliding downhill – now reports of war, not just an "operation" in Kuwait.

When I called a friend in Israel, worried about her and our friends there, she said, "The war is going to start tonight!" How did she know? She said they'd been given gas masks and told to seal off a room in case of a gas attack. We both began to cry. She was in Jerusalem and her children were in Tel Aviv, so she couldn't be with them. When we finally hung up, I sat and shivered in my chair.

January 17th, I watched the news alone in my office. Don was out of town. Just as Jim Lehrer went off the air, Peter Jennings came on. The air strikes against Iraq had begun. The Baghdad sky lit up with bombs. I didn't know what to feel except terror. I watched for hours, incredulous to be watching the bombing, knowing people were getting killed.

I called Susan a few days later. She said, "Things depend on what is going on in Moscow and the Baltic states, and we can't really do anything about it." The project was on hold. Susan felt sure it would happen though, in time.

On February 28th, the President, George H. W. Bush, declared a cease fire. The Gulf War was over. Then for months, no word came to us from the White House about the Soviet–U.S. treaty.

« « Signs of a Safer World » »

IN EARLY JUNE, A HINT. Susan wanted to make a change to the plaque. "Oh, God, no!" I said to myself. When I unwrapped our original plaque, I cringed at its rough background. I requested a new one, without the textured paint, and with Susan's change. A friend and neighbor, a Soviet émigré, kindly went over the Cyrillic text with me, and the plaque was cast.

Ah! Too soon. Another call from Susan to say we needed to add a line about Barbara Bush. (In Russian, for a woman's name, the husband's name is not typically used. Barbara Bush or Mrs. Barbara Bush was preferred.) I was glad to add her name.

Thanks to Susan, I liked her enormously. (I hadn't yet met either of them in person.)

Susan said nothing ever happens in government in August, so the momentum was on for July, for the treaty and the project. In early July, a reporter called to ask me to talk about how international politics affects artists. I confess, this project had sucked me right into the political scene. But the White House had made this rule, smartly: If the press called, I should get the name and number. When the State Department had approved interviews, we'd call back through the White House. The press getting interested signaled the treaty was pending. Also Susan needed to know where I would be day and night. Ollie's group had also been alerted.

A few days later, she left a message to say, "watch the news tomorrow." On July 17th, Mikhail Gorbachev, General Secretary of the U.S.S.R., asked President Bush to come to Moscow to sign the START treaty.

Susan had once said, "When we do move, we will move FAST!" She was right. Here came a memo to say we'd leave the next day. I read it, light-headed. A C-5B military transport plane, would fly from Andrews Air Force Base and pick us up, along with our fourteen tons of equipment, at Westover Air Force Base outside of Springfield, Massachusetts. We'd stop at a British air force base, and then fly on to Moscow. Also on the plane would be Susan, White House staff, the press corps, and eighty Secret Service.

Luckily, we were given an extra day before departure. The crates and heavy equipment had already been delivered to the base by Ollie's team. Now his five men and I arrived at Westover AFB on schedule. We watched, astonished, as the transport plane landed. Those planes stand six stories tall, the biggest in the world. They carry small airplanes, tanks, limousines, and platoons of soldiers.

Susan and her colleagues disembarked. It was fantastic to finally meet Susan in person. We hugged on the tarmac like old friends. Soldiers at the base loaded the plane. After a time, we climbed the stairs to board. Susan asked if I would like to sit in the cockpit when we took off. I jumped at the chance. I wore a giant headset, hearing the pilot and the ground controllers and their special jargon, which I didn't understand. I scanned the hundreds of dials, lights, and controls, and before I knew it, we were in the air. It was positively thrilling.

I was led from there to a flight cabin, which was like a living room, where Susan and I had dinner. Then we stayed in our "in-flight condos" – small bedrooms and showers. I changed into my pajamas, as always, and slept in a real bed. (I'd flown a lot but never like this.)

In Moscow, we were met by David Chikvaidze, a Soviet Georgian whom Susan had known in Washington. Their sons were the same age. David told us – me, the installation team, our interpreters, and others – what to expect in various situa-

tions. He was pleasant and his help was indispensable. He gave us phone numbers, maps, background notes, and a special blue dog tag with an identification number, which we were told never to take off when we left the building. We could not get into the U.S. Embassy without it, and it offered protection in case of trouble. He warned us about the surly guards at the entrance to the hotel, which was called The Sociological Institute. The guards were KGB.

Although things had certainly loosened up between our countries, one could nevertheless sense the fear and mistrust.

That first evening at the hotel, we met the Soviet men who would oversee the installation. Ivan Legkonogykh, the chief of construction, Alexander Tantlevski from the mayor's Cultural Affairs office, and Mark Shuty, the Department Chief of Perestroika Joint Venture. We all agreed to meet every morning for our week of work, to evaluate how it was going, and then meet every afternoon to discuss what we needed for the following day. David cheerfully and efficiently managed these meetings. This young Soviet diplomat with his dual knowledge of Americans and Soviets, coupled with equal knowledge of both languages, made the week run smoothly.

I'd asked for at least one interpreter to be on site at all times with us, and we did truly need them. The Soviet installation team always arrived on time, dispelling rumors Ollie was convinced of, that they'd always be late. Negative rumors we'd heard about Moscow weren't true for us. People we dealt with were cooperative, friendly, and helpful in every way.

« « On the Site » »

WHEN I SAW THE SITE IN PERSON I was deeply moved and burst into tears. It was a perfect setting in every way: the convent's golden minarets, black and white swans on the pond, a picturesque duck house, and the lovely park grounds, with forests and grassy spaces, all like an image from a fairy tale – magical for children and their families.

One of my first decisions was which direction the ducks should face. Should they be walking into or out of the park? What was the path of the sun? What sort of shadows would form around them? I thought Mrs. Mallard should be looking toward the water, in the direction of the convent and its beautiful architecture. With that, we started work.

The Soviets supplied a Bobcat to dig the trench for burying the cement footings. I brought out trinkets and coins given by people at home for burying with the installation as a good-luck gesture. Others contributed, and we all swore, laughing,

that we weren't superstitious.

The crates arrived from the airport, and the Soviets used a crane to offload them. The U.S. installation team — Gordon, Rui, the two Tonys, and Manny — carefully uncrated the ducks. As each one appeared, I felt a twinge of delight. I hadn't seen them for months. They'd been put away, ready to ship, since December. The frustration and anxiety of so many months now gone, I could notice with bemusement all the American flag stickers on wheel barrows, generators, diamond saws, on pretty much everything shipped from Massachusetts.

Susan, a constant visitor, decided where the plaque should go. We had fun talking about where the first ladies would stand, and the press, the singing children, the band, the invited guests. Rebecca Matlock joined us, impressing us all by dropping to one knee in the sand or dirt to photograph the Capizzi team lifting ducks into position. We liked her tremendously, and apart from her documentary photography, she was a major help to Susan.

One afternoon, the White House advance team arrived to evaluate the area for coordinating the celebration, and I admired Susan's remarkable skill at guiding decisions. Mrs. Bush said about Susan in her 1994 memoir that the ducklings had been a "happy and lovely gift," which had required endless planning and fundraising. "I got the credit," she wrote, "and did not deserve it: Susan did."

Around this time, I decided I'd better try to reach home to say I was fine. I missed everyone. One of the few direct overseas telephone lines out of Moscow happened to be in our Sociological Institute-hotel, but calls, for a reason not explained, had to go through Helsinki. Don had good news when we finally spoke. He and Bob McCloskey were coming to Moscow! Susan, of course, had made it happen.

The installation went well until we ran out of cobblestones. The work area measured eight by forty-five feet. The sculpture in Boston, from Mrs. Mallard's bill to Quack's rear end, measured thirty-six feet. David Chikvaidze to the rescue. He brought samples of black basalt cobbles like the ones in Red Square. (Black basalt is a fine-grained volcanic rock.) When the new cobbles arrived, I designed a pattern to incorporate them. I liked the commingling of stones, which for me was symbolic of how exceptionally well everyone had worked together, despite language barriers and occasional torrents of rain.

We finished installing Mrs. Mallard and her brood on Friday. Passersby had been stopping to watch. Children, who didn't know the story of the book, were nevertheless drawn to the sculpture, wanting to touch each duckling up and down the line and feed them grass and pebbles.

The Soviet team — Mark, Alexander, and Ivan — proudly showed me extensive plantings of vibrant flowers. The park and installation site had been cleaned up and

trimmed to get ready for the dedication. Moscow TV came by for interviews. The White House advance team returned. Work completed, Capizzi's team wanted to buy souvenirs for their families. The monastery had a state-run hard currency shop, Beriozka, full of goods at inflated prices. In abundance were traditional matryoshka dolls, one doll inside another, representing the continuity of life. A contemporary version, the Gorby doll, had Gorbachev as the largest doll. When you opened him up, inside was Breznev; open him then Khrushchev, then Stalin, then Lenin.

After making purchases, we returned to the installation site for a small party of champagne and vodka toasts at the trailer for the workers, a custom for the end of a project. The job was done and done well. Everyone could relax and share the sense of relief. The little glasses of vodka were raised, words spoken, someone hugged, and bottoms up. This went around, person to person – the vodka taken in one gulp after each toast. We stumbled into the van for the ride to our hotel, and a few heads were hanging out the windows.

Gordon and the team were very ready to head home to Massachusetts. Susan had gotten a flight for them for noon the following day, and she'd worked out, through many calls, how the equipment would be delivered separately to a military plane and flown back to the U.S. None of this had been easy. Unfortunately, she had no exit visas yet for the team.

The next morning, the guys were packed and waiting outside the hotel. Mark, of the Soviet team, arrived with two trucks, one for the Capizzi team luggage and one for the team itself. As soon as the exit visas were brought over by one of the U.S. embassy staff, Buck, off they'd go to the airport.

But the visas hadn't come. Time was getting tight. They couldn't afford to miss the plane. It might take days to arrange another. What was taking so long? I was in my room by the phone. (We had no mobile phones.) I didn't dare use the phone and tie up the line. Finally, the phone rang. It was Buck. He said Moscow had another building called The Sociological Institute – on the other side of the city! He'd been given the wrong directions. Instead of dealing with Moscow traffic again, he'd headed to the airport with the visas. He was waiting at the gate for the group. If you want, you can imagine me running out of the hotel lobby waving my arms and yelling that I had just gotten a call to say the visas were now at the airport. Go! The loyal and hard-working team and I hugged again, and I waved as the trucks disappeared down Leningradsky Prospeckt.

« « Prelude to the Summit Events » »

I WAS MOVED TO A NEW HOTEL, the Moscow Olympic Penta Hotel, so new it

hadn't yet opened. This, the hub for the Summit attendees – the President, Cabinet, staff – had the feel of a "command post." The lobby bustled with staff checking and counter-checking their clipboards. My room had been changed because Don would join me the next day. The room had originally been assigned to President Bush's personal physician. Strangely, the room had no drawer or closet for clothes. And a communications technician woke me to install a "sweep phone," which allowed calls from the room to any place in the world at any hour. A phone for the doctor, clearly.

Susan Porter Rose introduced me to John Sununu (Chief of Staff), Brent Scowcroft (National Security Advisor), Marlin Fitzwater (White House Press Secretary), James Baker (Secretary of State), among many others. During our stay, a few of them quacked when they shared an elevator with me. They seemed to enjoy it. The ducks were not stopping nuclear arms, but the gift of the ducklings was for the future, for the possibility of a peaceful one.

I was delighted when Rebecca Matlock invited me to a reception and dinner at Spaso House, the U.S. Embassy – a neoclassical mansion, grand and ornate, built for a wealthy industrialist by Russian architects who finished it before the Russian Revolution. I was glad my daughter Susie had said I should pack more than my tomboy clothes for doing installations in the trenches. The evening was an excellent trial run for what was to come.

And to my great joy, Don and Bob arrived the next day. With the help of White House staffers, we had time to tour Moscow. First, at Bob's request, we visited the ducklings. He was touched. We watched as the children patted, hugged, and "fed" the new ducks. It was Boston all over again. A film crew from ABC's *Good Morning America*, scouting the site, caught the children and Bob smiling ear to ear.

Before the formal events to come, we rested, toured, swam at the hotel, and saw more of the city with Julia, now our guide and interpreter – who'd translated Bob's book and was so pleased to meet him.

« « End of July, Dedication and Treaty » »

MRS. BUSH, BOB, AND I RODE together to the ducklings. At the site, a band played and children sang and waved flags. The mayor of Moscow, Gavrill Popov, spoke. Then Mrs. Bush: "These ducks are very important. They are a real symbol of the growing friendship and understanding between our two great nations. And when Mrs. Gorbachev and I are long gone, these little ducks are going to be here forever. There is something magical about the thought of American children loving and playing with these ducks, while the children in Moscow are doing the

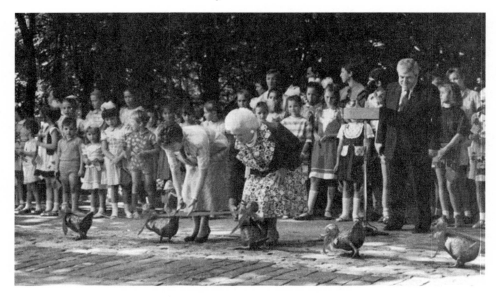

The Moscow dedication and ribbon cutting.

same. The shared laughter of these children will be just one more sign that our two great countries have many more things in common than we have differences."

Mrs. Gorbachev taught the children the names of the ducks – Jack, Kack, Lack, Mack, Nack, Ouack, Pack, Quack. In her speech, she thanked Mrs. Bush "for bringing these amazingly nice ducks here and making a gift of them to our little citizens. We are grateful to Robert McCloskey, author of the book *Make Way for Ducklings* for agreeing to present a part of his talent and a part of his kindness to our children."

The first ladies cut red ribbons tied from duck to duck, all to flashing cameras. Large bouquets were given to the first ladies and to me. Bob McCloskey and I were thanked, in Russian and English, by so many in the crowd.

Then I was whisked off to be on *Good Morning America*, scared to death at the thought of millions of people watching. The press called the gift "duckling diplomacy," and I was proud of that. One wit had written "Make Way for Dignitaries," and honestly, that was the case. Afterward, we were taken to the Kremlin for a State dinner. In the receiving line, President Bush said to me, "Barbara loves those ducks." I have no idea what I said in return. After the Bushes, I met Mikhail Gorbachev with Raisa, then Boris Yeltsin and Soviet ministers and politicians whose names I could not pronounce. Four massive chandeliers lit the way as Bob McCloskey and my husband and I were ushered into the Palace of the Facets. I hardly remember the speeches or our eleven courses, except for the huge bowl of caviar. "Overwhelmed" was a word Bob and I both used, feeling it in a good way.

The following day a bright sun shone for the moment the world was waiting for. We watched the START Treaty being signed on CNN, knowing it happened around the corner from us. Dinner at the embassy later, a wall of press in black suits, a spotlight on one table, where I would be seated. Dignitaries all around. For a moment, I was at a loss. But then a man approached. I offered my hand to shake and said, as I always do, "Hello, my name is Nancy Schön." He said, "Oh, hello, my name is Isaac Stern." I almost passed out. Then in came President Gorbachev himself, who bowed and sat at our table. Then Mrs. Bush. Next, Gorbachev's closest circle as well, along with Leo Tolstoy's great grand-niece. Mrs. Bush, a thoughtful woman, asked everyone to sign my program so I would have it.

After we ate and before Isaac Stern performed, he and I talked about Israel, since I had lived there. I knew of his February concert in Tel Aviv, which was interrupted by sirens warning of a Scud missile attack from Iraq. The orchestra left the stage, the audience put on their gas masks, and Stern, alone, performed a famously haunting Bach sarabande. Such courage!

Before I floated home on Stern's music, I turned to one of our interpreters, Vladimir, something of a joker who'd become like an old friend on the project, and asked whether he might translate something for me to Mr. Gorbachev. He said, "Sure, it's a free country." (I probably laughed but could only appreciate the irony of it later: Within weeks, the coup occurred.)

I told Gorbachev how wonderfully the Soviets and Americans had worked together. And I added heartfelt statements I hoped were profound.

The connection to Washington continued after I got home. In September, Barbara Bush, no doubt through the efforts of Susan, held a reception for me at the White House. Those who had contributed to the project – *any* amount, even ten dollars – were invited. And they came, along with my children and their families. It was spectacular! Walking freely around the White House was like a dream after the days in Soviet Moscow. I couldn't believe it was happening to me, that I was being honored, that I was talking with Mrs. Bush as if she were a friend. We lose sight of people of fame. We lose sight of ourselves, too. How did I deserve all this? I felt truly blessed.

After the restoration of the stolen ducks, Mikhail Gorbachev threw a large party to celebrate, which included speeches.

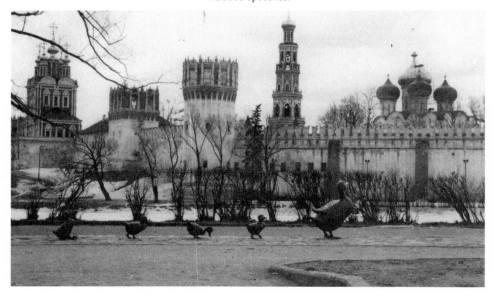

The sculpture is directly across from the breathtaking architecture of Moscow's 16th century convent, one of UNESCO's World Heritage sites.

The Make-Off-With-Ducklings Phenomenon

On February 10, 2000, a phone call.

"This may be sad news."

Anna Badkhen, from the Moscow Times, wanted my reaction to the theft of Mrs. Mallard and two ducklings. Sawn off at the knees.

I screamed in her ear. The poor reporter!

Two days later, Brian Whitmore, in a front page article for the Boston Globe, wrote, "Nobody ever said life in Moscow is for the faint of heart, but Mrs. Mallard and her ducklings have had a particularly rough time in Russia's capital. Apparently the victims of malicious nocturnal visitors bearing power saws, the Mallard family probably wishes it had never come."

After the 1991 Moscow installation, Quack, the duckling on the end, was stolen. Replacing Quack was not high priority during the coup and its aftermath. But this "mallard mischief," as Brian Whitmore called it, couldn't be ignored.

I began making calls and sent faxes to the current Russian ambassador and U.S. ambassador. As I was going down that path, another path opened up. I heard from Beth Hebert, an American in Moscow who ran Pallada Asset Management Investment Company, a subsidiary of State Street Bank and Trust in Boston. She'd loved McCloskey's book growing up. She and her husband took their daughter to Novodevichy Park, planning to videotape her with the ducklings. What they found was a cruel sight! All that was left of Mrs. Mallard, Lack, and Mack were their webbed feet. And Quack's little feet were still in the cobblestones, too. Long lost Quack.

Seeing the vandalized sculpture, Beth wanted to restore it. She felt so strongly about it. Here was a powerhouse with a great sense of humor and a tolerance for bureaucracy. In a couple of weeks' time, she managed to secure — from Moscow's mayor, the Ministry of Culture, and the U.S. ambassador — permissions and agreements, properly vetted, to say the ducks could be replaced. With this, she approached State Street Global Advisors for support.

Remember Henry Lee of the Friends of the Public Garden? With the help of his organization and their tax exempt status, we began the paperwork for raising funds.

Months of calls and faxes paid off. Other donors came forward. Delta Airlines took care of the flights for the crated ducks, me, and two of my daughters, Ellen and Bootsie who were so helpful to me. I loved having their company. Ellen was great at navigating Moscow, and Bootsie was great at keeping me calm.

After the ducks were replaced, Mikhail Gorbachev and his daughter Irina arranged a celebration for us. He wanted to keep the sculpture whole to honor his wife's name. Now it was complete.

September 18, 2000, about 300 people, including Beth, her husband and daughter, watched Gorbachev cut a large blue ribbon and unveil the completed sculpture. He said, "I look at those ducklings — this is a family. We in our family take this as tribute to Raisa Maximovna." The ducks reminded him of "wonderful days."

When it was my turn to speak, I had many to thank. I recalled how, for the first ladies, the sculpture was a "common great endeavor," bringing two nations closer together. I added that I hadn't known this day was the first anniversary of Mrs. Gorbachev's death, nor that she'd been buried in the convent's cemetery across the pond. She had found the most beautiful place in all of Moscow for my sculpture, and now she was "overlooking the ducklings forever." We all wept, including Mr. Gorbachev, who gave me an enormous hug and a kiss on both cheeks.

« 6 »

More in the Life of a Public Artist
Purloined Ducks, Sun Angles, Ollies, and Me – a Skateboard Nanny

If you want to become famous, just create a sculpture of a family of ducks
and make sure some of them get stolen.

GORDON GOODBAND, DURING THE installation of the Public Garden ducklings (way back in 1987), said wisely that he thought the sculpture would need a police detail that night. The cement needed time to set. An off-duty police officer in uniform was hired, but someone in the dark hours didn't do his or her job. The officer left the sculpture unattended, and Quack was stolen. Until the security of the sculpture could be assured, all the ducklings were removed. The theft and re-installation jeopardized the sculpture being ready for its formal unveiling. A large civic celebration had been planned, too, with a ribbon cutting – well, you know all that from Chapter One. But this was the first theft, and I was hysterical.

The police did not inform the press about Quack, nor did anyone else. We didn't want others to get ideas. I called the foundry in Connecticut. They needed to recast Quack, and it was urgent. I drove there the next morning to fix any wax imperfections so we could pour the bronze. All went well and the installation was completed again and just in time for the dedication.

Things were quiet for a while, and then stealing a duck seemed to be the "thing to do." Mack was abducted December 10, 1988. He was in the middle of the duckling line, making his absence particularly noticeable. Andy, my son, called me shortly after the theft. "Mom, have you seen where Mack was?" I hadn't. He said, "Someone has placed a great big egg in his place!" I had to laugh.

Two weeks later, I got a call from the Boston Police saying a duckling in a box had been left on the steps of the State House. I sped downtown to police head-quarters and opened the heavy box, and yes, a bronze duck looked up at me. But it wasn't Mack. It was the long lost Quack. I wasn't sure whether to laugh or cry.

That night on the news I watched the commissioner hold the duck and tell how Mack had been recovered. (The real identity of the bronze hadn't been discovered when the news was reported earlier in the morning.) The commissioner raised the duck above his head and water poured out all over him. What was this? Bronze sculptures are hollow, so I knew that somehow, the duckling had been near water,

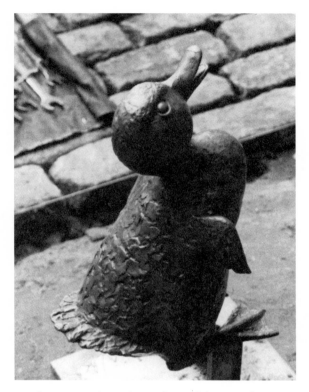

This isn't Quack, Mack, or Jack. A trick for remembering
duckling names is to follow the alphabet, from Jack, after Mrs.
Mallard, to Quack. (This one's Nack.)

but where or how?

A few days later, I got a call from a young man who was part of a dance team visiting Boston. Staying with a friend, he'd gone to take a shower and found a bronze duck in the tub. He told me he'd put it in a box and delivered it, but he wouldn't say anything about who had taken it or how.

Mack was still missing. Two devoted duckling lovers, Tommy Leonard (bartender at the Eliot Lounge) and Eddie Doyle (Bull & Finch manager at the Hampshire House, home of the TV show *Cheers*) launched a citywide "Bring Back Mack" campaign on February 8, 1989. The first event, a skating party on the Public Garden's Frog Pond. After that, soup and "quackers," and then dancing at the elegant Hampshire House.

Eddie tied yellow ribbons on the other ducklings as a symbol that Mack would be returned. Indeed, he and Tommy also raised funds by selling circular pin-back buttons that said Bring Back Mack. It seemed every child in Massachusetts wanted a button, they wanted Mack back so much. I was touched that Tommy and Eddie

cared, and their effort provided the money for recasting and installing Mack.

What to do with the returned Quack, since we had already replaced it? Quack was accepted by the Boston Public Library Children's Room to honor Peg Mc-Closkey who'd died in October 1990. Peg had always believed in the project and supported my creation of the ducklings.

Another theft. No peace! *I can't stand any more!* Ouack was stolen in January 1992. Thanks to the generous donations made by lawyer David E. Shellenberger and David Brilliant, president of Sporto Corp, and another campaign by Tommy Leonard and Eddie Doyle, and the support of Red Sox player Mo Vaughn, whom the kids began calling Ouackman, a new Ouack could be cast. The duckling was reunited with his siblings on June 26, 1992.

I'd hoped I wouldn't have to deal with any more pranksters. I was wrong, oh so wrong. I had a few quiet years, admittedly. The bad news came from the Boston Parks Department right before Thanksgiving 1999. Jack was gone. The late Thomas Menino, Boston's mayor at the time, described the theft as "a cowardly and thoughtless crime," and he quickly authorized funding to replace the missing duck.

Later, after Jack was replaced, a librarian at Boston College called to say a duckling had been found in a library carrel. It was the original Jack, now with an injured webbed foot. Mayor Menino and I started getting letters and phone calls from heads of hospitals with children's units. Many wanted the recovered Jack. I let the mayor choose. Jack went to the New Patients Facility at Boston University Medical Center. Many children who were treated there came from families with limited means. Then the Celtics donated money to create a fourth-floor rooftop playground where Jack was installed.

In 2000, I'd got the call about the nightmarish theft of Mrs. Mallard and two ducklings in Moscow. You can see why, after all the Boston thefts, I screamed into the phone to the reporter.

Again, all was quiet, until April 2009 when a park ranger in Boston discovered Pack, the second to last duck, on Beacon Hill (a neighborhood close to the Public Garden). I was quoted as saying, "I really can't imagine why anyone would want to steal a sweet little duck and make the kids who love these ducklings unhappy." Mayor Menino gave a strongly worded statement. "This act is not a prank; it is a crime." He added that perpetrators, when found, would spend six months in jail and pay $50,000.

Those poor ducks. If you are reading this and don't live in New England, perhaps you know how severe our storms can be. As well as hurricanes and blizzards, we have nor'easters, sprawling and sometimes dangerous storms in which high

winds can gust to 70 miles an hour. Remember those two trees that framed the walkway Suzanne and I, so long ago, thought was the place to represent Mc-Closkey's story with a sculpture? One of the trees crashed on top of Mrs. Mallard and her babies during the high winds of a bad storm. The damages were quickly repaired. I suppose if you are stuck outdoors and cannot fly away, this is your life. Seriously though, this is my wish: that the ducks, whether with red bows around their necks or hats on or sports jerseys, will stay together as one family, with none stolen, without damage, ever making their way, to the delight of all.

« « Sundial Goddesses » »

IT TOOK FIVE EARTH REVOLUTIONS around the sun for this project, from start to finish. I'm including it in the book to show that not *everything* I do is based on children's literature or is related to animals. I can get my back up if I'm thought of as only the ducklings sculptor, though I am grateful beyond words for the friend-ships, experiences, and even the gray hairs both of the ducklings projects gave me.

The sundial commission spanned 1999 to 2004. The sculpture was to honor the nursing profession and they deserve it. Nursing is timeless and has been with us for eons. For many nurses, it's a 24-hour, 7-day-a-week job.

At first, I didn't know the sculpture would be related to time. The conceptual stage – in which I examine and reject ideas, make lists of associations (whether words or images), dig into histories, talk with others, and engage in brainstorming with clients – is stimulating and I love it. But when the concept has to embrace a large subject, it can take awhile. The more you learn, the more you need to know.

A meeting in 2001 included me and two dozen nurses and higher-ups at the hos-pital which was commissioning the sculpture. The nurses shared insights into their profession – they have to be communicators, they have heart and brains, some are in patient care, some teach, some conduct research. They juggle many things, deal with bureaucracy . . . They had ideas from all directions, and passion, and they further stimulated my imagination.

After about six months of researching, interviewing, and trying out different de-signs, I hadn't arrived at anything that felt right. One day talking with my daughter Susie, she noticed I was unconsciously drawing circles and talking about Time. "Are you drawing a sundial?"

That was it!

With this, I wanted to show the history of nursing. The gnomon is the triangular piece of a sundial that shows the time by the position of its shadow. I would put three figures, symbolic ones along the thickness of the gnomon, who would repre-

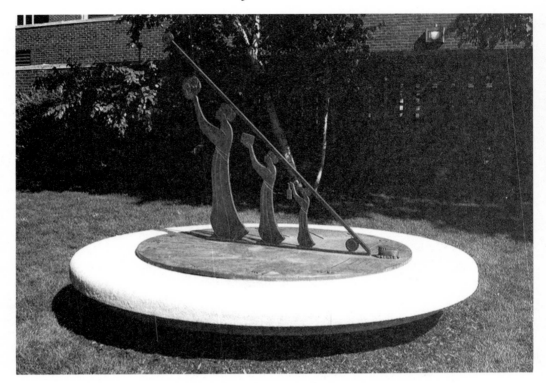

The sundial installed, telling time, and honoring the nursing profession.

sent the past, present and future of nursing. One would carry a lamp (historic connection), one would hold a book (intellectual and educational connection), the last would carry a globe (international connection). I thought of the figures in bronze relief. I'd long been intrigued by Greek sculpture, and the next thought – Greek goddesses. The figures would be in flowing classical robes.

Much of my work before I created the ducklings was figurative, of women and children for example. I'd loved Henry Moore's work, but also Giacometti's elongated figures. Flowing classical robes, too, was a style that came easily to me from friezes I'd made with Edna Hibel.

How does one make a sundial that tells the correct sun time? The library supplied books on equatorial sundials, horizontal sundials, vertical sundials, and polar dials. Horizontal dials are appropriate for garden settings. I made one in cardboard to understand how it worked. But I was far from making one in bronze. I mapped out on paper a seven-foot diameter sundial on the floor of my garage. I drew degree lines. To make a sundial you need the latitude of the site, or the angular distance north or south of the equator. (The latitude for Boston is 42.35833 degrees.) The more I learned, the less sure I was of being able to build one. Corrections

[84]

between watch time and sun time were needed, because the earth moves faster some parts of the year. Watch time is based on mean time, which was invented to ensure safe and accurate train travel and synchronization across regions. The difference could mean as many as sixteen minutes.

And what about daylight savings?

The mathematics required trigonometry. Time to call on experts.

James E. McLaren, a mathematics teacher, gave me accurate numbers and a schematic, for being sure the sundial could be read as a timepiece. I could not have accomplished that without his help.

I made a mock up. The dial would need a pedestal, a site with sunlight, inscriptions and Roman numerals in appealing fonts, and a bronze replica of a nurse's cap. To me, the circular pedestal (for the goddesses) represented the circle of life – nurses are present at the beginning and end of life. The inscriptions from wise nurses, including Florence Nightingale, were chosen.

The proposal was accepted, but the project began to feel as if it had a dark cloud over it. Little by little, I glimpsed the politicking going on – those who didn't want to spend the money, those who wanted it smaller and elsewhere, and the like. But I had the casting to do, and a slab of granite to order. I hired an architect, Meliti Dikeos, who was young, gifted, and patient, to review the site and compute the sun calculations for the sculpture. The ground under the sculpture had to be free of obstruction and allow a hole 42 inches deep for footings to reinforce it. The sculpture would weigh a half ton, the pedestal would weigh six tons, and the footings two and half tons.

Because of conduits, electrical wires, and underground pipes, described as "a jungle," Meliti and I had to rethink the location. The best location was next to a 30-foot trailer in place for a nearby construction site. The trailer could not be moved in time for Nurses Recognition Week. Could the sculpture be temporarily placed and installed later?

Gordon of Capizzi Company, ever professional and helpful in so many similar predicaments – who could do most anything and do it right – talked to me about options. His solution was approved. A week or so before the May 3rd celebration, he and his team poured a ten-foot slab of concrete at the temporary site. They drilled holes in exact registration with the bolts on the base of the sundial. After the base concrete set, a huge crane brought in the bronze sculpture, which was thrilling to watch, and lowered it. The drilled holes were filled with hydraulic cement, the bolts were slotted in. Six men and I stood on the sundial and held it securely for a half-hour while the quick-drying cement set. Done!

A few months later, the construction trailer was moved and the sundial would be

landed on its granite pedestal as planned. The ten-foot granite slab was cut in two, otherwise it would have been vulnerable to cracking. Also it's *six-ton* weight made it dangerous to put down and take up, and if it happened to become damaged, replacing it would have been expensive.

Finally, the sundial was placed so it told time, as it should.

Things got snarly over payment, promises, details. After a vindictive threat to my reputation and my need to hire an attorney, I had a meeting with one of the nursing executives. Issues were settled. There were no lawsuits.

I never thought those problems could happen. There'd been so much approval and love at the dedication. But everyone doesn't always have the same point of view. I had a stone in my heart for a while. In time, the positive side of the project showed itself more and more. None of us can do anything like this without support from others, and many people were indeed generously supportive. Still, it takes persistence, tenacity, honesty, patience, determination, endurance, commitment, and stamina! And for me, what has made all the difference is that I love what I do.

<h2 style="text-align:center">« « The Skatepark Story » »</h2>

THIS IS ONE OF my favorites, from not so long ago, and I've saved it for last. Think back to the *Tortoise and Hare*. It took seven long years for those two sculptures to arrive at their finish line. Put that together with news that they were being defaced not long after they were installed. Why would this be a favorite memory, you might wonder.

A kind person from the Friends of Copley Square called to tell me that skateboarders, doing their ollies and grinds, or whatever, were damaging my sculpture. I was furious. *Skateboarders...ugh.* Indistinguishable from hoodlums in baggy pants. That was my image of them. I'd confront them. I drove to the square and, in anger, started to yell at the kids.

But I pulled back. They were nothing like the negative stereotypes I'd expected. These skaters were skillful athletes, not smokers or drinkers or pot heads. They were terrific. They told me skateboarding is against the law in Boston and Cambridge, and in most other towns and cities. Some of them had been taken to the police station, fined, and had their skateboards confiscated.

This exchange happened in 1995, and I wanted to help them out. They needed a safe and legal place to practice. I became an advocate rather than an adversary. I began working with the Metropolitan District Commission to create a world-class skateboard park. My goal was to get others passionate about the idea, too.

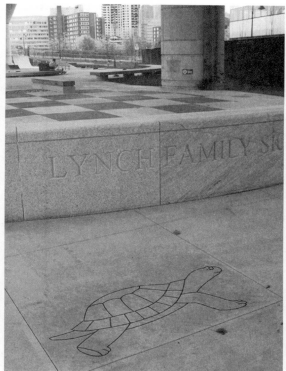

The Tortoise and Hare etched in cement honors how the Lynch Family Skatepark came about.

The nonprofit Charles River Conservancy, founded in 2000 by the dynamic Renata von Tscharner, spearheaded the effort for the construction of a 40K square foot skatepark, to be located under Boston's Zakim Bridge – a stunning cable bridge and Boston landmark. (Full name: Leonard P. Zakim Bunker Hill Memorial Bridge. Lenny Zakim was an activist for civil rights and led the Anti-Defamation League in New England.) I joined the Conservancy board. Some of Renata's landscape architect students at Harvard's Radcliffe Seminars made skatepark designs as assignments. Meanwhile, the state legislature developed a bill for finding a location. The Charles River Conservancy conducted a national search for concepts and chose a California-based skatepark designer.

In 2004, more than 400 local skateboarders and other skating athletes attended public design meetings. Rad, punk, tattooed, pierced – it did not matter. A real park for trying a "half cab noseslide" or some other trick was better than streets, public sculptures, and historic landmarks.

Fundraising took place over many years, and behind the scenes I did what I'm good at, which is getting people together, raising awareness, getting people excited

about supporting a project, and raising money. Funding also came through the state, nonprofits, and corporations. The Massachusetts Senate and House approved funding for the park in 2005, but Republican governor Mitt Romney vetoed it. He was overruled a year later.

Carolyn and Peter Lynch of the Lynch Foundation "got it." I feel as if they trusted me and believed in the project. Carolyn was a powerful force behind it, and they came forward with a substantial challenge grant.

Legal work began. Who owned the proposed land? The park would need a staff and maintenance. Builders and engineers were hired, let go, and new ones brought on. The soil was tested and showed contamination – another important concern to be addressed properly.

In 2012, the skating community attended charrettes with key people from the construction and design companies. These are meetings to look at every angle of a project, to bring up concerns, to problem-solve, compromise, and make final decisions.

After construction was completed, the park opened in November 2015. Two thousand skaters showed up, and I was invited to stand with Renata and the wonderful Lynch family as they cut the ribbon. Now I'm known as Skateboard Nanny or the Grandmother of the Lynch Family Skatepark.)

Skateboarders still skate in Copley Square. I'm told they leave the sculptures alone for the little kids who want to play on them. I don't know whether or not this is an unspoken courtesy or completely true. But I think Boston and Cambridge stepped up and recognized a need.

The Charles River Conservancy is now striving, admirably, to make the river safely swimmable. I swam in the river as a girl – and fed its ducks with my brother and sister, which is somewhat ironic, looking back.

The skatepark demonstrates what's been true for several of the projects I've described in this book: It can take many years for a public project to come to fruition. No matter how beneficial the idea, not everyone will be for it. Unexpected setbacks happen. Some committees are pokier than tortoises, or they're easily swayed or distracted. *Many* people are involved. When you aren't in the middle of it, when it's not your art at stake, it might be viewed as comedy, some of it. Sometimes the achievements are too hard won. Other times, the sources of pride, or the constant experiences of learning and discovery, fuel enthusiasm all along.

Skateboarder using the park after its opening.

One Door Closes, Another Opens

I thought my career was over. I thought my world had fallen apart. I didn't know what to do. Real estate was changing in New York in the early 1980s. The prestigious gallery I had been showing in told me they had to close. Their rent had skyrocketed. The gallery was on Madison Avenue between 78th and 79th Streets on the ground level adjacent to the famous Forum and Matisse galleries. Here I had shown my work in their large street front window. Here was the gallery in which I had a show that included Rembrandt. How could they close?

This disaster turned into an entirely new and rewarding pathway. Brandeis University commissioned me to design a benefactor pin to raise money for their library. Brandeis Magazine's "Imprint" section wrote a brief profile and said, "Her work reflects her life around her and the bonds of affection and joy that people have for one another." This unusually successful venture became a turning point in my career. I discovered I could design small bronze sculptures, awards, donor walls, and gold or silver jewelry to raise money for institutions. I could help others, do what I love to do, and earn a fee at the same time.

Over the years, I've dedicated a large part of my creative life to raising money for institutions: nursing homes, colleges, hospitals, schools, and nonprofits. When I was very young, my mother often said, "Cast your bread upon the waters. It will come back to you." There's a warm feeling that comes with giving back. I love that feeling.

A Series of Bronze Fables

Being a public art sculptor isn't like being an employee of a company, just the op-posite. Yes, I go to work every day in my studio, but who says there's a commission to work on? Sometimes there's a long hiatus between commissions. Sometimes the well overflows, and I have two or three projects going at once.

During a period in which I found myself without a major commission, I had to transform how disheartened I felt into a feeling of renewed energy. It's a cycle for me: anger, crying, feeling worthless, and then getting charged up and active again. My computer can be my friend when I'm in this cycle and want to think. I ask myself questions and use my thoughts about the answers to explore the internet. In this case, I was thinking about how much I'd loved my mother reading aloud to me. Also, I've always liked magic, and I'm intrigued by symbolism, which permeates so many aspects of life. Life's lessons — the meaning in things — intrigue me. Ah! Aesop's fables — life lessons in abundance. My sculpture Tortoise and Hare *was inspired by the many ways the fable seemed perfect for the marathon runners — how they don't give up, no matter how slowly they might cover the miles. As I thought about Aesop, I was amazed that more than 2,500 years after he lived, we were still quoting him:* Slow and steady wins the race. Honesty's the best policy. Look before you leap. Don't count your chickens…

I decided to explore more about Aesop and his fables and perhaps find a new idea for a public artwork.

There's much we don't know, in fact, about Aesop, supposedly a former slave who'd been freed for his wit. Oral storytelling traditions passed down hundreds of fables attributed to him.

The Greek alphabet has 24 letters. This would make a nice series, I thought, and chose 24 fables that wowed me as I read them. One good turn deserves another. Even great wealth is worthless if it has no purpose. There's a time to work and a time to play. Do what I say, not as I do. A bird in the hand…

Making 24 maquettes felt like creating a legacy. This new work is very different from my other work. For the moment, I imagine the series as my magnum opus. Though who knows what will come next?

How Bronze Sculptures Are Made

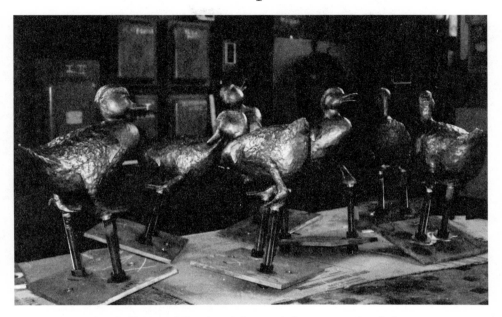

Cast ducklings on their rods and plates ready for permanent installation.

EARLIER IN THIS BOOK, I explained the maquette stage and armature building, and described how I create clay models. This section gets us into the foundry. Bronze is made of copper and tin. It's an alloy that's been in existence for more than 5,000 years. Copper is soft; tin is brittle. But combined, the result is a harder metal. In ancient times, this harder metal had uses in weaponry, tools, and sculpture. Today, foundries add silicone and other metals for even greater durability. My foundry uses a bronze alloy composed of copper (mostly), about three percent silicon, and less than one percent of manganese. It's easy to cast and excellent to weld, the fabricators and welders say, and for me it has an appealing tactile quality. It's durable and is bright in the sunlight, too.

« « Making a Waste Mold and Plaster Replica » »

ONCE I HAVE SCULPTED CLAY over an armature to make the model for a sculpture at full size, the next step, when following a traditional process, is to duplicate the clay sculpture in plaster of Paris. This replica is a kind of insurance. You might need it in the future should anything happen to the rubber mold or molds made for the bronze casting. (A plaster replica will last a long time, whereas a rubber mold

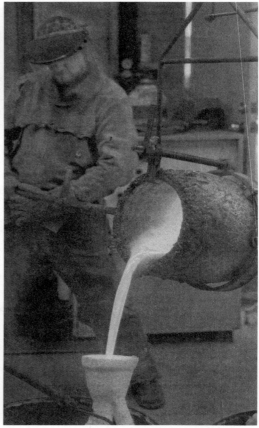

(*left*) Vicky Guerina making a waste mold. (*right*) In the foundry, molten bronze being poured into a slurry ceramic mold.

can deteriorate. Rubber molds are described below.)

For a plaster replica, you make what's known as a waste mold. It's called a waste mold because you'll chip it off. It isn't used again.

Using a brush, then a spatula, you coat the clay sculpture with layers of wet plaster. The first layers are thin, to be sure the details of the sculpture are captured. Then thicker plaster is applied. Molds might need to be in two parts so they can be separated after they set. The edges of the parts will need to match up, and there are techniques to ensure this. Some sculptors use shims and make registration "keys" in the plaster.

After the plaster sets, the two pieces are carefully separated with a hammer and chisel at the edges, and then gingerly pulled apart. I use putty knives and other tools to complete the separation. The clay sculpture is cleaned up and put aside. The plaster mold is cleaned with water.

To make the plaster positive from the mold halves, I first brush the inside of each half with an "oily" releasing medium. This will allow me to remove the plaster positive from its plaster mold. I put the two halves of the mold together and seal the seams (the edges) with burlap-soaked plaster and other reinforcements (clamps, for example). This prevents leakage when you pour fresh plaster into the mold. The plaster sets, and now you have a plaster sculpture inside a plaster mold. Chip off the outside mold – the waste mold. Spend careful hours working the surface to remove imperfections. Otherwise, you'll have to do it over. This plaster positive might be used as the basis for making a rubber mold in the future. Your clay model will be long gone.

« « Rubber Mold » »

MANY SCULPTORS, WHO PLAN to cast their work in bronze, skip the plaster rep-lica step – it is time-consuming – and go straight to making a rubber mold. A rub-ber mold is made by brushing on several coats of silicon rubber, or a polyurethane compound, either of which is formulated to capture details in the clay. More rub-ber is added with a spatula after the "early" layers are dry. This increases the thick-ness of the rubber. Foundries perform this step for me, which takes several days.

Over the rubber layer, a "mother mold" of plaster is layered on and allowed to set. The mother mold helps hold the shape of the rubber. Because this mold, too, has to be separated, it is made in pieces. For the ducklings, these molds were in two pieces, halves, (but did not include their wings, bills, legs, or feet, which were cast separately).

« « Wax Positive and the Poured Metal » »

HOT WAX IS POURED INTO each rubber mold to a consistent thickness and then cooled. The wax layer is about a quarter-inch thick. When the wax sets, it is re-moved from the rubber, and the wax pieces are put together in alignment. Seam lines are removed, and with hand tools, I carve or touch up any imperfections. This is called chasing.

The wax model is hollow. It is dipped in ceramic or silica slurry several times, drying between each dip. This forms a ceramic mold, which is about a quarter-inch thick. The mold can withstand high heat. First it's put in a burn-out oven, and the wax is "gassed out," or melted away. (That's why this process is called "lost wax.") Then the shell mold is put in a kiln to bake, hardening it to withstand high heat – for molten metal. The metal is poured in when the ceramic is still hot from the kiln, for the bronze positive. Wherever wax was, is now metal.

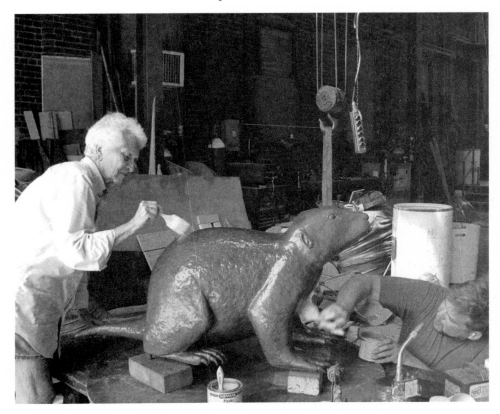

The final step in the foundry is patining the finish.

« « Refining and the Patina » »

THE METAL COOLS AND IS TAKEN from its mold. After the ceramic layer is cleaned off, the metal pieces are welded together. (If it's a duckling, there are two main body pieces, as well as legs, feet, wings and beaks, which have to be properly positioned and welded on.) Next comes chasing the metal and then polishing it, to ensure the welded seams are not apparent. A patina is brushed on with heat and chemicals and adds color. I make sure I am present for this. Not only are there different colors – soft green or dark brown, for example – but there are highlights. For outdoor sculpture, a protective coating in wax is the final step.

Afterword

« Becoming an Artist »

CHILDHOOD'S A TIME OF TACTILE PLAY, of shapes and surfaces. I think of the ice blocks brought to the house by the ice man; the foil cigarette papers we kids collected, soaked, and layered into balls for the war effort in the 1940s; the tiny silver balls on high peaks of frosting on tiered wedding cakes in the bakery window; and the cake bakers themselves, short ladies who tucked their white hair into fluffy "shower-caps." There were the Hoodsie ice cream lids with photos of movie stars, which we traded like baseball cards. There were the Mason jars filled with water and arsenic (yes, arsenic) for collecting Japanese beetles. My brother Earl and I got a penny for every beetle we pulled off the rose bushes and drowned in a jar.

As far back as I can remember, my hands worked for my father's florist business. Those times may have taught me about working in three dimensions or shaping a form, but what I learned most had to do with hard work, patience, diligence, and a long list of positive values that helped me later in completing public art projects.

My father, Harry Quint, was the oldest of fourteen children. He was born in Lithuania and was seven months old when he came to the United States in 1887 with his parents. They settled in the Roxbury neighborhood in Boston among other Orthodox Jews.

As a little kid, he peddled flowers in Back Bay, which is an area in Boston of filled-in tidal marshes. Once filled, the land was built on – massive churches, townhouse mansions, parks and smaller townhouses in the "English style." He led Kitty, his horse, and trundled through the cobblestone and muddy streets, calling out "Fresh flowers for sale!" He could claim he had the freshest flowers because his wagon was a "conservatory on wheels." It had a glass structure on top to protect flowers from heat or cold. This was inventive, nobody else had anything like it. All the money he made went back to the family, as more children were born to his mother Annie. The family hardly had anything to eat. A little sugar on stale bread was considered lucky.

My father grew up to become highly respected and successful, running the most fashionable florist business in Boston. He bought greenhouses and small parcels of land out in Newton. There he raised wholesale and retail plants and blossoming trees for a landscaping business.

He wanted so much to get out of anything that looked like or reminded him of a ghetto. Later I gained an understanding of old Boston and how he admired the

Some of Nancy's sculpture tools in her studio.

"blue bloods," the Brahmin families, who were his customers, and how he worked hard to rise above his background. I can remember him talking to a wealthy customer in his shop as though he had a hot potato in his mouth and then going into the back room and speaking Yiddish to one of his designers.

Later, too, I came to realize how many he helped or completely supported – his relatives, including his mother's family still in eastern Europe, my mother's young cousins who'd lost parents in concentration camps, friends, the families of his gardeners and greenhouse workers when there was need. My uncles, his brothers, worked in the business with him. He set up a store for his sister. The list is long.

My brother Earl and I worked in the greenhouses before we were as tall as the counter. My father would buy day-old newspapers in bales, which neither Earl nor I could manage alone. Our job was to climb on a box, cut the tie on the bale, open the papers out flat on the counter and pile up the sheets until they were two-fingers thick. We'd then roll the paper up like a jelly roll, tie it, and stack the rolls into pyramids for storage. In those days, delivery trucks didn't have heaters. In winter, each plant had to be wrapped in newspaper prior to being wrapped in nicer outer paper. Newspaper kept the plants from freezing before being delivered. Poinsettia flowers had to be wrapped in cotton as well, so they wouldn't freeze. At Easter, we snipped red pollen from the stamens before wrapping the lilies in cotton and then newspaper. We had to disbud the carnations, crinkle colored foil onto the pots, and tie bows around them.

We were not doing this alone. We were surrounded by my uncles, by Jack the

Scandinavian grower and his assistants, and all the Italian workers. But even with so much help, there was always more to do. The business was the art of rotation, long-term planning, understanding clientele, and knowing well the plants, trees, flowers – and their timing. The greenhouses had cellars underneath where pots of bulbs were stored. The bulbs would be forced gradually for holidays – Thanksgiving, Christmas, Valentine's Day, and Easter. Christmas was the hardest. There were churches to be decorated. Homes needed wreaths and swags and centerpieces. Restaurants, hotels, and other businesses needed flower arrangements. The basic swag and wreath work required twisting wires. The strong hands of the Italian gardeners did this, and I and others added ribbons and artistic "baubles." Many times, though, orders came in late, and I would make wreaths on my own.

It was New England cold outside. The greenhouses had heaters, but it was chilly and damp work. My hands were covered in sap. My fingers ached and stuck together. (Making sculpture later didn't free me of rough hands, but I've gotten accustomed to them.) As the days came closer to December 25, the work became a frantic juggling act. We'd labor well into the night, if not all night, finishing orders for the next day.

Summers were freer. One day a large truck arrived at our house and 500 yew trees were unloaded and planted. As they grew, all of us kids and neighbors played cops and robbers among them. Trees would disappear, being transplanted into people's gardens. My father planted and rotated roses and flowering bushes around the front yard. These would disappear, too. The Italian gardeners – who'd come from Italy as young men to work directly for him – planted vegetables for *everyone*. They planted a grape arbor and made wine. They famously saved our beloved apple tree when it was uprooted during the hurricane of 1938. In the fall, at the rumor of frost, we'd all rush out and pick whatever was edible and then wrap tomatoes in newspaper to store in the cellar.

I believe my father truly loved his business. He was good at it – personable and smart – and worked hard to solve problems and find ways to make the business run well. He was very particular about how a flower arrangement looked. He liked to do things his own way, and of course he had many flaws, as do we all. But I learned so much from him, most especially not to shy from back-breaking work.

When I walk into a space that has lush plantings – the Isabella Stewart Gardner Museum courtyard in Boston, for example, I'm taken immediately back, with great pleasure, to the smells of the greenhouses and my father's shop.

On my mother's lap, posing with my brother and sister, circa 1932.

"One of the busiest Boston retailers was Harry Quint. His advertisements were bold and catchy and he had a great call for wreaths from all New England points. His garden scene outside the Boylston street store always attracts notice." June 1916 Florist Review, *referring to Memorial Day business.*

Grandfather's greenhouse where my father loaded his horse-drawn wagon to sell fresh flowers around Boston.

THERE WAS A TIME IN MY TEENS when I was a mess. High school, especially, overwhelmed me. Cliques formed. My closest friend started going to a church group. She pulled away from me, possibly for many reasons, but one was because I was Jewish. She and her family liked me a great deal, I knew. Her father even said to me later that he'd have loved his son to marry me, if only I weren't Jewish. That's the way it was then in the 1940s (and earlier).

I'd encountered anti-Semitic taunting in grade school. I had a good friend in those years named Lizzie. She was Italian. We walked home from school together. Older kids threw things at us, calling me "kike" and calling Lizzie a "dirty wop," or maybe I was the "dirty" one. We fought back, being tomboys and good at running fast. This endeared Lizzie and me to one another. (We remained friends for seventy-odd years, by an occasional note or phone call.)

In my high school years, World War II was in the background, affecting everyone. I had friends and was playing in sports and leading the band as a drum majorette; still I was unhappy. I felt misunderstood, as many do at that age, and I was struggling with identity. I began rejecting my Jewish heritage as my father had. From an early age, I'd disliked the classes at the conservative synagogue we went to. I did not like learning Hebrew by rote, never knowing what we were reading or what it meant. I'd turned away from religion of any kind. As I saw it, it was hypocritical. People said one thing and did another.

Now I couldn't find a place where I fit in or that fit with what I believed. I told my parents I would do better in a smaller high school. When there was a problem, my parents didn't talk things over with us – with my siblings, Conny and Earl, or with me – and they tended to spoil me. I can look back and see that my emotional chaos needed structure and direction. I needed guidance and good teachers who loved to teach. The new school I went to, a girl's private school, was indeed smaller, but I did not thrive there, except in art class. Worse, for the long run, it was academically lacking. When it came time to go to college, I was not prepared. It wasn't long before I dropped out and was back at home. I was in a terrible slump.

« « The Turnaround » »

As IT HAPPENED, Lizzie's older sister Catherine had moved back home, too. She was a talented sculptor, and I looked up to her. She'd married and had a little boy, but the marriage broke apart, and she broke down. Her doctor during this difficult period said, perceptively, that it might be therapeutic for her to take clay onto the wards of Boston Psychiatric Hospital and teach sculpture once a week to some of his patients. She asked me if I'd like to join her. What an amazing experience.

Some patients sculpted and worked with us; some took out their aggressions on the clay. I observed Catherine over those many months. She had the soul of an artist. I'm sure she had an influence on my interest in becoming a sculptor.

During my slump, my sister, Conny, encouraged me to take classes while I worked and sorted it out. At Boston University, courses in aesthetics and Greek drama were well taught and excited me. Things began to turn around. Conny's friend Merrilyn Delano had just returned from a year in Europe studying art. A wonderful artist, she gave me lessons, and over time I built a sculpture portfolio. I re-enrolled in Tufts College and got a degree in Sociology, and I was accepted into the Museum School in Boston to study sculpture.

I was lucky. Many young women at the time had no way to go to college nor were they encouraged to. Many colleges and universities did not accept women into programs. And on a personal level, I was supported by a loving family while I pulled myself together, which did not happen overnight and no doubt was as confusing for them as it was for me. In time, I became more accepting of who I was, that I was Jewish. My attitude about many things changed, and my life became, active, optimistic, and rewarding.

« « A Studio of One's Own » »

SCULPTORS NEED SPACES THAT CAN get dirty. The materials we use are messy. Unlike painters, we don't need north light, just consistent all-around light, so we tend to get relegated to basements. I spent four years in the basement of the Museum School as a sculptor student. My fifth year was a teaching fellowship, so I went upstairs from time to time, to the drawing and painting studios, and critiqued the work of younger classmates.

I got married in December 1952 and graduated from the Museum School in June. My husband Don and I moved to California, where I had a thumbnail studio in a cramped garage. I tried to create small things. Next we moved with the Army to Hickman Mills, Missouri. I had two babies by then and no place to work on sculpture. Then came Kansas City, where I tried to eke out "studio space" in a corner of our bedroom so I could make direct-plaster figures. What a mess!

A few more moves, four children, no time, and no space. I think for most artists, lack of money is a big factor in not having enough space to work. And for female artists of my generation, not having enough money for babysitters prevented us from having uninterrupted time for creative work. That's probably still true today. Now it's called day care.

When two of our children were in school and two were still at home, we could

finally afford more frequent babysitting. We moved into a house with a basement and attached garage. I started teaching in the garage. The students were young mothers much like myself. The garage had a few windows, and in warm weather when the door could be raised, it became a marvelous space. I worked in the garage at night, making pieces in cast cement and plaster of Paris after the children were asleep.

When we moved to Washington D.C. for Don's job, Don's career accelerated into high gear, full of social events, not to mention the challenges of my caring for four children in a new place. I did make some sculpture, but I lost momentum.

But not too much time passed before we moved to Newton, Massachusetts, where I'd grown up. I could teach classes again, and got going on my own work. However, I was back in the basement, and I didn't like it.

Newton is close to Boston, and on visits to Boston's Museum of Fine Arts, I fell in love with small Etruscan bronzes on exhibit. I could work in wax for small pieces, and I could afford to cast small works in bronze. I decided to move my workspace upstairs to the bright sunny room my husband used as an office. Sharing a room with one's husband can be complicated, to say the least. Nevertheless, I was lucky enough to show my work in a gallery. I felt as if a dream was coming true.

I jumped at the chance to sublet a studio in a converted school classroom. I could drive right up to it – no stairs to climb with my arms full. It had one whole wall of windows, running water, and a custodian who kept the studio floors polished. There was no telephone. There were no children, friends, or relatives. No dishes to be done, no lack of light or space. I had freedom – and space to work, all to myself – I'd never known. Not long after getting settled there, the ducklings project came about. The studio gave me elbow room and "head space" to build those ducks, and it was such a pleasure to work large in plaster and clay, and to get really, really dirty.

It's one thing to become an artist. It's another to stay at it. I was helped by a mentor, who once said, if you are a beginner, you must work constantly or you lose ground. Across my career, when I didn't have time or space for the constant, intense focus one needs to develop and understand the work one is doing and wants to do, yes, I did lose ground. I had to "begin" again in new spaces. My mentor was right. She said, "Momentum is essential, and you can get lost without continuous effort."

Her name was Edna Hibel, and she changed my way of thinking. I listened to my gut, which she advised. I became more confident. Her gallery in Boston was the first one I showed in. She lived in Boston and Zurich. She also had a gallery in Florida and eventually a museum there in her name.

As I've been writing this book, these words have crossed my mind many times: "Edna taught me that." I came across a quotation by me in a Boston Herald feature story on a show of mine. I said, "We are all the sum total of our experiences, and for an artist I think you have to have some experience of life before you can really understand what it is you want to say." That's pure Edna. I was 47 when I said it.

Edna was almost 98 when she died, and her legacy is still going strong, inside me and, I am sure, inside many other artists.

Here are several more of her observations I feel are helpful:

• One cannot separate one's daily life from one's artistic self.

• An artist can't wait for things to be perfect, the perfect light, perfect materials. It will never come.

• Art is not a case of moods. It is a serious, full-time job. The times you don't feel like working are times you've reached a plateau. Learn to recognize the signals and understand what that frustration means. Use it as a time of growth. Study anatomy or design, or draw or read. Refill the well.

• Know the tools of your trade. The more you know, the freer you are to express yourself.

• Don't talk about it. Do it. You can only learn by doing. (My husband believed this, too. I have a quote of his in my studio: You can't learn to design if you don't do design...doing it is the only way to learn it.)

• There is no substitute for hard work. You may think there are many things you have to give up to be an artist. However, once you channel your activities, you quickly learn you haven't given anything up. You've gained a larger, much more exciting world.

• Never say, "I'll fix it later." Do it now. (I wrote this on a windowshade in my studio, so I'd always see it.)

• If you work on many pieces simultaneously, you can afford to be more adventurous and less fearful of making mistakes. You'll be freer on every level.

• Take advantage of accidents, but don't rely on them to happen.

• An artist must please herself, must believe in herself, must be true to her philosophy and ideas. Ignore criticism, good or bad.

• Surround yourself with the best. Don't fill your head with the copiers of the copiers of some movement. Read about the masters. Understand their philosophies. Look at their work constantly. Expose yourself to only the best art.

• When is a work finished? When you love it, not until then.

Acknowledgments

« I Could Not Have Done It Alone »

I'VE HAD A GOOD, LONG LIFE AND CAREER, which means my list of people to thank is long, too. In my original manuscript, I'd mentioned pretty much everyone, because that's how I think. But at the excellent suggestion of Sue Ramin, Associate Publisher of David R. Godine, Inc., I've kept names to a minimum in the chapters. Here, in this section, I can sing out all kinds of praises and share a few more stories as a way to express my appreciation for the many who have supported me and my work.

I thank Sue Ramin and David Godine wholeheartedly. David is known for publishing beautiful books. Some are art objects in themselves. They are a rich visual and tactile experience, and as an artist, I feel fortunate this book is in such good hands.

My most profound thanks to Frankie Wright, my editor, who came to me as a stranger and will be leaving me as a cherished friend. Her insights, her knowledge, her patience, her talent, and experience pulled my 88-year-old life into the adventure it has been, so far, into a book.

The thought of publishing a book about my public art gave me a jolt of energy. Suddenly I'm reviewing photos and clippings, confirming dates. It was a process of looking back and remembering people – many amazing people – and it led to deep gratitude.

« « The people Bob McCloskey and the ducklings brought to me » »

BOB MCCLOSKEY CHANGED MY LIFE. He was supportive when I was new to public art, and I treasure the times we spent watching children talk to the bronze ducklings and pretend to feed them. Bob was sensitive and intelligent. He and his wife Peggy, who was a children's book librarian, kept a low profile. I admired that, and I miss them. Peg died in 1988 and Bob in 2003, at 88.

My dear friend Caroline Bloy was known and loved for putting people together. She died in 2011 at age 86 – I miss her and can hear her husky voice and laugh even now. I'm forever grateful she thought it was no big deal to call up Bob McCloskey and tell him about the sculpture idea.

Suzanne de Monchaux came up with the idea of honoring McCloskey in the Public Garden. She and her husband John were from the UK. He was dean of the MIT School of Architecture and Planning at that time. He and my husband were colleagues; soon Suzanne and I were. Suzanne and John's expertise in urban de-

sign helped with our proposals and presentations to public art committees. Thanks
to Suzanne, I met Mary Shannon, who directed the Boston Arts Commission
through the Boston mayor's office. She had a big job because Boston's collection
of public art is one of the largest in the United States. Mary advocated for public
art. She understood that artists can be intimidated by paperwork and meetings and
approvals. I was, and she was a great help.

Through Mary, Suzanne and I met Henry Lee, the president of the Friends of
the Public Garden. He lived on Beacon Hill, his neighborhood, right next to the
Public Garden. He was distinguished looking, pronounced garden as "gahden,"
like a true Bostonian, and had the kindest smile for everyone. He loved that people
of all ages came to the garden because of McCloskey's book. His wife Joan Lee is
another for me to thank for her support over the years.

The Friends of the Public Garden protect the Garden, the Boston Common, and
the Commonwealth Avenue Mall, which is a mile long, tree-lined promenade ("a
grand allée") faced by 19th-century brownstones. The promenade connects the
Public Garden with Frederick Olmsted's historic Back Bay Fens. Henry Lee, Edgar
Driscoll, and other members of the Friends of the Public Garden committee have
my sincerest thanks for sponsoring my sculpture, and, too, for their work of caring
for the historic green spaces downtown.

Ellie Reichlin, a curator at The Society for the Preservation of New England
Antiquities (SPNEA), an essayist, and a friend, told me about Nancy Coolidge when
I was in a panic about fundraising for the ducklings. Nancy Coolidge was the busi-
ness mind and backbone of SPNEA, now known as Historic New England. Adopt-
ing public art was not a new concept, but in Nancy's hands, adopting ducklings
– even before they hatched in bronze – made the sculpture possible. I am grateful
to her for that and for the heroic work she did to ensure the Moscow ducklings
were properly funded. Susanna Crampton, her secretary, also should be thanked,
as well as Lorna Condon.

Nancy Coolidge brought Peter Lynch and Carolyn Lynch, and their important
foundation, into the world of the ducklings. Peter Lynch, a former investment
"rock star," has written several financial investment books, but is probably better
known as a philanthropist. He and Carolyn Lynch adopted ducklings; their foun-
dation helped fund the dragon sculpture in Dorchester, and it raised large sums for
the skatepark, which is named for the Lynch family. My admiration and gratitude
for their goodwill goes beyond words.

Duckling supporters and adopters also included Ellen (Westy) and George Love-
joy Jr.; Carol and Avram Goldberg; Anne and Arnold Hiatt; Elizabeth and Ned
Johnson; Mr. and Mrs. Ismael Dudhia; Mr. and Mrs. Robert J. Owen; and Norman

Leventhal. Thank you all!

The Boston Public Library, known locally as the BPL, played a role in the ducklings story. Sinclair Hitchings, for many years the curator of prints and drawings at the Boston Public Library, had wide-set eyes and a brain full of art historical knowledge. He generously agreed to let me study and copy the archive of McCloskey's drawings for *Make Way for Ducklings.*

Peggy McCloskey had died in 1988, and in 1991 when Quack was recovered, Suzanne de Monchaux and I donated him to the Children's Room at the BPL in Peggy's memory. (This Quack – stolen, replaced, and later left in a box on the steps of the State House like an orphan – had an adventure, though we don't know what it was.) I'm delighted Arthur Curley, director of the BPL, was enthusiastic about having Quack.

The innovative and generous Morton Schindel, who founded Weston Woods, made videos animating Bob's books. He and Bob were lifelong friends. Schindel received a lifetime achievement award from the Library Association when he was 86. He died at 98. One reason his films were so appreciated by librarians and lovers of children's books is that his films stayed true to books and their illustrations. I could relate to that when making sculptures inspired by McCloskey's illustrations.

The people at Viking Press, McCloskey's publisher of *Make Way for Ducklings,* who were helpful included Regina Hayes, publisher of Viking Children's Books; David de Jardines, Publicity Manager; and Jazan Higgins, who is now a vice president at Scholastic.

And for casting the first brood, my thanks to Ronald Cavalier and his team at the Renaissance Foundry in Bridgeport, Connecticut.

« « The Ducklings Go to Moscow » »

THEN CAME MOSCOW. My experiences before, during, and after Moscow are a tribute to the patience of others who dealt with me here on the home front. It took many minds and hands – locally, in Washington, and in Moscow – to pull off the international event.

Barbara Bush had an excellent staff at the White House led by Susan Porter Rose. She was phenomenal. Mrs. Bush's staff and press corps included Ann Brock, Kim Brady, Sandra Haley, Anna Perez, Jean Becker, Sally Runion, plus Caryn Danz, Cultural Affairs officer, all of whom I thank.

In Moscow, I was standing next to Barbara Bush on July 31, 1991, when she was being interviewed by CNN reporter Bernard Shaw. I found this in my notes from the trip. It shows why I was rather star-struck by Mrs. Bush. (Shaw was known

for asking questions that corner people in politics, in the hopes, one assumes, that they'll say something newsworthy or damaging.)

Mr. Shaw: You are one of the most intelligent, astute persons, as is your counterpart Raisa Gorbachev . . .

Mrs. Bush: I know this is going to be a terrible question.

Mr. Shaw: . . . and because of that, to see you juxtaposed with *ducks* . . .

Mrs. Bush: Aaah. Those ducks are very important. They are a real symbol of friendship, and when Mrs. Gorbachev and I are long gone, those ducks are going to be here. And it's been a wonderful experience . . . The Russian workers and the American workers worked together so beautifully, and when they were through, they hugged each other. It's a wonderful thing that this little sculpture will be here forever."

I'm grateful to her for those words.

Speaking of star-struck, after the installation of the ducklings and the treaty signing was a new experience for me of state dinners and a parade of dignitaries – the cabinet of George Herbert Walker Bush, Soviet president Mikhail Gorbachev and his officials and politicians, as well as Isaac Stern and his second wife Vera, who stayed in touch with me afterward.

Those who worked hard for the duckling gift to Moscow's children included Rebecca Matlock, to me an unsung national treasure, who did intense and unending diplomatic work with her husband Jack Matlock, the U.S. ambassador in Moscow. I'm deeply grateful to them. Anne Meyer and David Rose, the co-founders of CAST, supported the project. Gordon Goodband was president of Capizzi Company. What a great person. It would never have happened without his level head. Many thanks to Tony Capizzi, Anthony Antonio, Manny Rocha, Rui Vincente, Bonnie Spellmeyer, and Rebecca, and everyone else, over the years, from Ollie Capizzi's skilled and energetic company.

James Alexander, principal of Finegold Alexander Architects, Inc., in Boston helped with the Moscow project, working with me to prepare what the architect and staff in Moscow needed for the installation. He and Maurice Finegold, like so many, shared their expertise with remarkable care and civic-mindedness.

My thanks to wordsmith Barry Wanger, Martin Roberts, founder of Linguists Systems, for his efforts on the Russian plaque. David Chikvaidze, Vladimir Lobatchev, an ambassador of the USSR and our translator, and Nina Barysheva, another of our patient interpreters, and Henry Quilan and Charles Kelley, thank you.

Cari Best, children's book writer and wife of Mort Schindel sent me a copy of the Russian version of *Make Way for Ducklings*. Many, like her, have generously helped me fill in gaps for this book project.

NANCY SCHÖN

« « Ducks Gone Missing » »

FOR YEARS, THE STOLEN DUCKS were a nightmare, and I truly thought it would never end. I'm reluctant to write much about all that, except the incidents provide examples of community spirit. Two devoted duckling lovers I especially thank, Tommy Leonard and Eddie Doyle. They took some sting out of the pain with their "Bring Back Mack" campaign. I also thank Thomas Kershaw of Hampshire House.

Moscow's stolen ducks brought Beth Hebert into my life. She made me laugh. Her diligence in navigating red tape with good humor got the replacement project going and funded, beginning with Pallada Asset Management and State Street Corporation. I thank her and her family. Through that project, I had the chance to experience a loving tribute to Raisa Gorbachev by Mikhail Gorbachev and their daughter – and their gratitude for me. That was a moment I shall never forget.

I thank those who have thoughtfully given or sent me photographs of the ducklings, whether in Boston or Moscow. For example, the woman who sent me photos of the Boston ducklings and Mrs. Mallard after the tree fell on them. I'm sorry I no longer have your note to include your name here. I was so relieved the damage was not as bad as I would have imagined.

« « The Bronze Race on Copley Square » »

IT SEEMS MY LIFE HAS ALWAYS been intertwined with Copley Square. My father had a charming flower shop at the corner of Newbury and Dartmouth streets for fifty years. All through my growing up, I worked in his shop and later delivered flowers all over the Back Bay. I celebrated my twenty-first birthday in the Oval Room at the Copley Plaza Hotel (now the Fairmont). I went to Boston University for two years in classrooms in the cellar of an abandoned church on Newbury Street. The very first art gallery I showed in was on Newbury between Dartmouth and Exeter.

It was fitting, then, that I met Stella Stafford and Phebe Goodman of the Friends of Copley Square, whose efforts helped land the *Tortoise and Hare* in its permanent site. They did this, along with Justine Liff, Kenneth Crascoe, Mildred Farrell, Director of the Boston Art Commission, Anne Harney Gallagher, the George E. Henderson Foundation, Boston's Mayor Thomas Menino, Capizzi Company, and the New England Sculpture Service's Jim Montgomery, Charlie Hahn, and oh so talented Marjee Levine. I also thank Ed Godfrey, Mel Shuman, Susan Rogers, Bonnie and Stephen Simon, Ronda Halverson at Kennedy Center, and Keith

Lockhart and the Boston Symphony Orchestra. I'm delighted the *Tortoise and Hare* is also ingeniously sited at the Crystal Bridges Museum in Arkansas. My thanks to the original curator Chris Crosman, Alice Walton and the staff there.

« « Museums, Universities, Libraries, Community Leaders, Supporters » »

I'M LUCKY TO LIVE IN A REGION with a high number of universities, museums, and libraries. I thank curator Meghan Melvin of the Museum of Fine Arts for including me in the 2016 Robert McCloskey exhibition. The Wenham Museum organized the wondrous "Animal Tales: Sculpture of Nancy Schön," a retrospective including my public art and other bronze animals from my collection for children to interact with. Jane Bowers, Exhibitions Curator and Manager, put together one of the most creative and lovely shows I've ever had. Kristin Noon, the museum's Executive Director, and Peter Gwinn, Director of External Affairs, were wonderful, as was my friend Joanne Patton, and Derek and Rebecca Smith, who are members of Wenham's board of directors. I'd also like to thank Winifred Perkin Gray for buying one of the pieces with such enthusiasm.

Among several talks I've given in 2016, the one at the Eric Carle Museum in Amherst, Massachusetts stands out. It was like sitting in a living room having a conversation. I loved it. My thanks to Executive Director Alexandra Kennedy and Rebecca Goggins. Eric Carle, a wonderful author and artist, will always have my admiration. I thank him, Motoko Inoue, Nicholas Clark, the founder and retired curator, and my good friend Leonard Marcus who is on the museum board and is an internationally acclaimed children's book historian.

In 2017, the Regis College Art Gallery is mounting a retrospective of my early work, which they are calling "Metamorphosis." Very fitting, I think.

Librarians, archivists, scientists, curators – they are underpraised and indispensable, and I want to thank them all. I am indebted to the beloved Virginia Tashjian, former head librarian at Newton Free Library who liked Eeyore and the message the character gave. The Children's Department was dedicated to her. Kathy Glick-Weil, Jean Holmblad, Nancy Johnson, Phil McNulty, and Nancy Perlow, library directors and heads of research at various times for the Newton Free Library, helped me out and were instrumental in creating a respected civic institution. But there are many on staff there who deserve acknowledgment whose names I don't know. Dottie Reichard, former president of the library's board of trustees, a friend – my thanks to her, as well as to another friend, Nancy Criscitiello, also a former board president when Pooh was approved and dedicated.

I'll mention Bernard Margolis here. He was head of the BPL from 1997 to 2008.

He was a supporter of my work, and in 2000, he flattered me in a letter saying I ranked among the most eminent of female American sculptors. That's the kind of statement that keeps one going! Margolis came to the dedication ceremony for the dragon sculpture in the Dorchester park, joining many other notables to read a dragon story or tell a dragon tale.

Mayors of Boston and Newton (Thomas B. Concannon, David Cohen, and Setti Warren) have championed my work. I particularly thank the surviving family of Mayor Thomas Menino, who supported him in his civic administration and leadership through five terms, which included giving speeches and attending most celebrations of my public art. Thank you to Joe Kennedy III and Ed Harding of Channel 5,who presented me with the Newton Cultural Alliance Award.

The diligent Ruth Clarke, along with Magnolia Monroe Gordon, has done much good for residents of Dorchester, Massachusetts, by "fighting crime with flowers," her motto. I deeply thank them for believing in the power of sculpture.

The Hamilton Community Foundation has helped to make Hamilton, Ohio, a "city of sculpture." I am pleased my work is part of it and I thank Walter Klink for the beautiful park for Lentil. To the children's gardens in Oklahoma City and Boothbay Harbor, and the people near and far who've supported sculpture that children can interact with – Nancy and John Abbott, Kaki and J.P Smith, Jane and Preston Haskell, Barbara Alford, Maureen Heffernan, Wendy House, Joseph Ledbetter (and his remembrance of a friend), the Roxbury Tenants of Harvard, the St. Guillen family, Roxanne Haecker and those who created the River of Life park, and Barbara Pryor and Andrew Pryor, you have my admiration.

Art makers, art lovers, art curators – I am glad you are keeping art in the world: Chris Crosman, Diane Smith, who had the idea for the Nurses' Sundial, Peter Slavin, MD., John McArthur, Dean of Harvard Business School, and Susan Rogers, dragon lovers, led me to David and Patty Sexton, dragon purchasers, whom I thank. I can't thank the foundry owners and craftspeople enough. To those I've mentioned, I add Daniel Kendall at Sincere Specialty Fabrication in Chelsea, Massachusetts; Robert Alfred-McGann Foundry; Charlie Precourt of Precourt Architectural Stones. Thank you to Rosalie and Jim Shane, and John Finley of Saxonville Studios.

« « Other Worlds » »

I'VE BEEN FORTUNATE TO TAKE PART in the work of nonprofits. First I want to celebrate the skatepark and those who made it happen: Renata von Tscharner

and her work founding the Charles River Conservancy is a fantastic story; Ronald Axelrod, Dan Calanao, Catherine Donaher, Gina Foote, Debra Isles, Mark Kraczkiewicz on the conservancy board; and the Lynch Family Foundation.

These remarkable organizations stand out: REACH (Refuge, Education, Advocacy, Change) works to end domestic violence through community action and sheltering women. I created a plate with a duckling on it for one of their fundraisers. The REAL (Reading Educational Assistance Learning) Program, started by Jan Plourde. I thank her for advocating on my behalf for public art. This group gives books to children and tutors them in reading.

Journey to Safety (JTS), the Jewish Family and Children's Services, is a philanthropic service organization for all faiths, ages, and races. Their advisory board: Elizabeth Schön Vainer, Director, Amy Chartock, Cheryl Weiner, Debby Belt, Elaine Goldberg, Ellyn Harmon, Julie Gladstone, Julie Goschalk, Julie Riven Jaye, June Ferestein, Lauri Meizer, Lisa Laniado, Louise Posner Silverman, Miriam Osiach, Wendy Wilsker, and Elaine Cohen.

« « Journalists, Photographers » »

MANY WRITERS AND PHOTOGRAPHERS have covered my career, often with humor and care. From the *Boston Globe* I have been celebrated by Gloria Negri who wrote about the *Tortoise and Hare*, the "purloined" ducks, and many other projects. Thomas Grillo also has my particular thanks for his many articles. (He also wrote for the *Boston Business Journal*). Susan Bickelhaupt, Martha Byington, Sarah Brezinsky, Maria Cramer, D. C. Denison, Richard Dyer, Bella English, Zeninjor Enwemeka, Bill Greene, Tom Herde, Fred Kaplan, Yunghi Kim, Thomas Landers, Linda Macham, Wendy Maeda, George Martur, Linda Means, Margo Miller, Evan Richmann, David Ryan, Rosalind Smith, Rhonda Stewart, John Tlumackl, Jonathan Wiggs, Brian Whitmore, the *Globe*'s Russian correspondent, and Mark Wilson for his amazing photographs. From the *Boston Herald*, many thanks to: Ted Archer, Laura Brown, Roberta W. Coffey, Michael Fein, Ted Fitzgerald, Lee Ann Gunn, and Carol Kort. From the *New York Times*, I thank journalist and photographer Anne Driscoll and photographer Richard Freidman. "Duckling Diplomacy" was the perfect term used by writer Carey Goldberg of the *Los Angeles Times*. Similarly, from the *Guardian*, Polly Basore Elliot's article title was "Make Way For Dignitaries (ducks from children's story waddle onto world stage)".

Channel 5 has been kind to me, too. I thank Paul LaCamera, Stella Gould, Ed Hardy, Amy Hassan, Natalie Jacobsen, and Kelley Tuthill. I remember Chet Curtis with fondness.

Charlie Gibson interviewed me for "*Good Morning America*" when I was in Moscow. I can't say it was fun, but it was an honor. Anna Badhken from the *Moscow Times* called to talk with me. My thanks to Eleanor Randolph and others at the *Washington Post* who included me, both for Moscow and for the *Tortoise and Hare's* visit to the Kennedy Center. I am grateful for those in journalism working independently. David Wurzell took many excellent images of me working. Though he is no longer alive, I want to put my gratitude in writing. I thank, too, Curtis Ackerman, Christopher Baldwin, Joseph Berkosky, Judy Best, North Cairn, Marty Carlock, Greg Cook, Sonni Efron, J. Denis Glover, Leslie Inman, Karen Jameyson, Diane Kilgore, Emily Myerow, Laura Mozes, Connie Parle, Luanne Pryor, John Sachs, Susan and Michael Southworth, Gail Spector, Karen Cord Taylor, Will Traub, Gail Weesner, Judy West, Kalman Zabarsky, and Zeninor Enwemeka. So many and so supportive.

« « Friends and My Personal "Art Committee" » »

DEAR FRIENDS HAVE COME TO MY AID in a thousand ways. I thank Sherry Turkle who teaches at MIT who sparks ideas; Anita Diamant, lovely novelist who inspires me; Pembroke Kyle, historian and photo archivist; Janna Kaplan, my Russian neighbor who painstakingly went over the Moscow plaque text and translations with me; Helen Meyrowitz, soulmate, who encouraged me to make Officer Michael from McCloskey's book; Patrick Pietroni, physician and writer who owns a number of my sculptures; Ruth Wertheimer, who commissioned *Dancing Girl* for the Edmond and Lily Safra Children's Hospital in Israel. My friends Charlie Kravetz and John Davidow are forces at WBUR. Also, Eileen McNamara, writer, journalist, and professor at Brandeis.

Lincoln, Massachusetts poet Craig Hill and his wife Heather have been friends for many years. I was thrilled when Craig agreed to recite his translation of Jean Le Fontaine's version of *The Tortoise and the Hare* at the sculpture dedication. Craig's presentation added a bit of elegance to the occasion.

Many thanks to all those who've "been there" in friendship and elbow grease:

Vicky Guerica, Hilary Hutchinson, Katie McGuinness, Bruce Heller, Vince Tersegno, and Barry Abramson, Anne-Reet-Annuziata, Barbara Apstein, Joan Barsamian, Robert Bloom, Arthur Broder, Harriet Christina Chu, John Cohen, Emily Corbato, Laura Foote, Patti Grossman, Marietta Joseph, Benet Kolman, Susanne McInerney, Susan Shulman, Jeanne Stolbach, Jan Tormey, Rich Tormey, Becky Tulchinsky. We have history, this group: Maggy Bruzelius, Susan Cohen, Mary Ellen Efferen, Mini Jaikumar, and Lois Natchez. You've been superb emotional

support over our years.

My family – I have been indeed fortunate. How could I not thank them? Ellen, Andrew, Elizabeth, and Susan were my first art committee – children who inspired my work. Their children have kept bright and vivid, in my artistic mind, the way children interact with the world. David, Claire, Jackie, Mia, Hannah, Julia, Sivan, Ben, Zeke, Charlotte, Natalie, I adore you all. And I have the gift of a great-grandchild, Josephine. To Gadi, LeeAnn, Lauryn, Drew, Mike, Jill and to supportive spouses past, present, and in the future, I thank you.

« « A Last Word » »

Finally, after mentioning the years Bob and Peg McCloskey died, and writing that Suzanne de Monchaux had died, and dear Carolyn Bloy, I stopped calling attention to the fact that some I have thanked are no longer with us, though they are very alive to me as I look back. I hope their families and friends know how much they did for art, how much they contributed to a positive experience and joyous fun for children, skateboarding athletes, library patrons, or marathon runners.

COLOPHON

Bembo is a 1929 old-style serif typeface based on a design cut by Francesco Griffo around 1495. It is named for the poet Pietro Bembo, an edition of whose writing was its first use. The revival was designed under the direction of Stanley Morison for the Monotype Corporation around 1929, as part of a revival of interest in the types used in Renaissance printing.

This book was designed and typeset by Sara Eisenman.